IMAGES of America

JAMESTOWN EXPOSITION
AMERICAN IMPERIALISM ON PARADE
VOLUME I

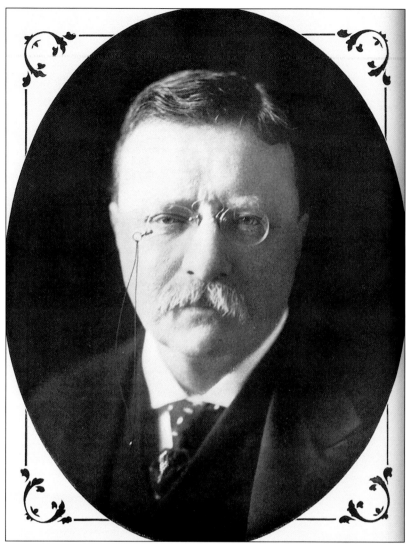

The Jamestown Exposition of 1907 was, in so many ways, a powerful reification of American imperialism, and President Theodore Roosevelt, shown here as he appeared c. 1906, embodied its spirit of intent in his personal character and presidential policies abroad. In a letter, restated below, the exposition was intended to serve the world notice of America's rich history and powerful place on the world stage. Making Hampton Roads that world stage, Roosevelt followed progress toward the exposition's opening day with keen interest.

 White House, Washington, March 9, 1904.

 "My Dear Sir: I trust I need hardly say to you how important I regard the proposed Ter-Centennial celebration to be held on the borders of Hampton Roads in 1907. This Ter-Centennial will mark an epoch in the history of our country. The first permanent settlement of English-speaking people on American soil, at Jamestown in 1607, marks the beginning of the history of the United States. The three hundredth anniversary of that event must be commemorated by the people of our union as a whole. With best wishes, believe me, Sincerely yours, (Signed) Theodore Roosevelt. To Mr. G.T. Shepperd, secretary, Jamestown Exposition Company, Norfolk, Virginia."

IMAGES
of America

JAMESTOWN EXPOSITION
AMERICAN IMPERIALISM ON PARADE
VOLUME I

Amy Waters Yarsinske

ARCADIA
PUBLISHING

Copyright © 1999 by Amy Waters Yarsinske
ISBN 978-0-7385-0102-4

Published by Arcadia Publishing
Charleston, South Carolina

Printed in the United States of America

Library of Congress Catalog Card Number: 99-62632

For all general information contact Arcadia Publishing at:
Telephone 843-853-2070
Fax 843-853-0044
E-mail sales@arcadiapublishing.com
For customer service and orders:
Toll-Free 1-888-313-2665

Visit us on the Internet at www.arcadiapublishing.com

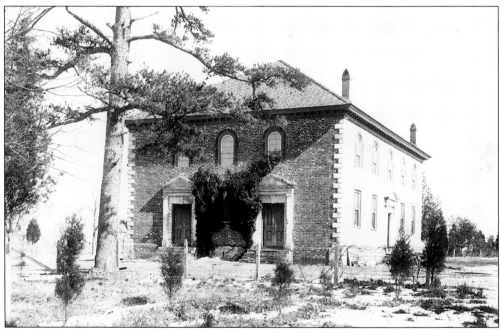

Pohick Church, an active Episcopal chapel, is located in the Fort Belvoir vicinity of Fairfax County, Virginia. The Georgian-style exterior of Pohick Church is reminiscent of dissenter chapels built in eighteenth-century England. The church, built between 1769 and 1774, is ascribed to James Wren. George Washington and George Mason served on Pohick Church's vestry at the time it was undergoing construction. The doorways, so prominent in this Harry C. Mann photograph from 1907, were carved by the church's mason, William Copien, from Aquia Creek stone. Restoration of the church was underway when this photograph was taken. Union troops desecrated the church during the Civil War, using it for a stable just as they had done in most of Virginia's historic churches in their path. Restoration began in 1901 and was not completed until 1916.

Contents

Acknowledgments 6

Introduction 7

1. Birthplace of a Nation and a Native American Princess 17

2. A Lesson in Virginia History 39

3. Clearance and Construction 51

4. Party Plans and Souvenirs 59

5. Palatial Palaces and Government Participation 77

6. Opening Day Pomp and Circumstance 95

7. On the War Path 103

8. The World's Fair in Hampton Roads 113

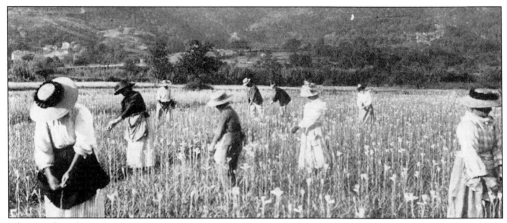

The Frederick F. Ingram & Company, perfumers, of Detroit, Michigan, gave away this trade card as the company's souvenir at the Jamestown Exposition. The women in the picture are gathering tuberoses for the manufacture of fine perfumes. The photograph was taken near Grasse, situated in southern France. The French Alps are in the background. (Courtesy of the City of Hampton.)

Acknowledgments

The process of working the material for *The Jamestown Exposition: American Imperialism on Parade* into two volumes was an arduous task, made all the more formidable by the amount of information to pare down and place judiciously in one or the other volume. Though my personal archive, a treasure trove of images, souvenirs, and documents, was the source of most of what you will discover in both volumes, I was able to add immeasurable depth to each volume as the result of further research through the University of Virginia's Alderman Library and on-line archive; the University of Michigan's "Making of America" program and on-line document research; the Library of Congress; the United States Naval Historical Center, the center's archive and on-line source material; Columbia University's archive of oral histories, in particular that of Hillary Beachey; and the Hampton Roads Naval Museum. The acknowledgments for both volumes would not be complete without mention of Jim Zwick at Syracuse University for his recognition of the influence of America's imperialism on the American expositions of the late nineteenth and twentieth centuries. Jim's on-line publication of critical and original archival material on the subject should be commended—and is—for the quality and profundity of material that is now readily accessible to researchers. His Senternaryo/Centennial worldwide web site is outstanding.

I would especially like to thank Michael Cobb, of the city of Hampton, whose devotion and appreciation of history and its importance to who we are as a community, a region, and a commonwealth is critical to all of our tomorrows. Had Michael not suggested several images and provided access to volumes of children's work exhibited at the Jamestown Exposition, some of the richness of the story of the exposition in Hampton Roads would have been sorely missed. These volumes are dedicated to Michael, his consummate professionalism and generosity, incredible knowledge and love of history, and a friendship we have shared for many years—and hopefully many more to come.

It almost goes without saying that I would not have finished these books without the love and support of my husband, Raymond, and our three precious gifts from God, Ashley, Allyson, and Raymond III. When I think of Raymond, I nearly always think of him as the light of my life, and invariably the immortal love lines of Thomas Moore (1779–1852) come to mind: "No, the heart that has truly lov'd never forgets, / But as truly loves on to the close, / As the sun-flower turns on her god, when he sets, / The same look which she turn'd when he rose."(1)

Introduction

In his speech at the Pan-American Exposition on September 5, 1901, President of the United States William McKinley called for the expansion of America's commercial interests abroad, more merchant marine ships, construction of a canal through the Isthmus of Panama, and laying of a Pacific cable. His speech was tinged with overtones of national interest and concerns, which he concluded were "good work" which "will go on—it cannot be stopped. These buildings [at the exposition] will disappear. This creation of art and beauty and industry will perish from sight. But who can tell the new thoughts that have been awakened, the ambition fired, and the high achievement that will be wrought through this exposition." Much of the same could be said for all the expositions held between 1851 and 1935. McKinley and, later, President Theodore Roosevelt are the presidents most closely associated with America's imperialistic policies, policies which Edgar Lee Masters (1869–1950) concluded swept America's shores at the end of the war with Spain. "Its water had lapped the foundations of other governments long before," wrote Masters, "and even in America discerning intellects saw the drift of the current as early as the war between the states."(2) Senator Henry Cabot Lodge (1850–1924) warned after his election to the Senate in 1893, that the United States would be compelled to enter the race for its share of the "waste places of the earth." With nothing left of the American frontier to conquer, the United States looked beyond its borders to the nation's manifest destiny abroad. After the United States' success in the Spanish-American War, McKinley and his supporters rallied the American people to push expansionism.

The McKinley-Roosevelt era was the honeymoon of imperialism, but also of the expositions held in the United States in the first decade of the twentieth century. These expositions and fairs, from the Trans-Mississippi Exposition held in Omaha, Nebraska, in 1898, to the Pan-American Exposition of 1901, the St. Louis World's Fair of 1904, the Lewis and Clark Exposition of 1905, the Jamestown Exposition of 1907, and the Alaska-Yukon-Pacific Exposition in 1909, were intended to showcase the military strength, technological progress, and vision for America's course in the remaining decades of the century. All of these objectives were lofty and ambitious, yet the floodgates of possibility flowed wide-open as the United States government footed the bill for each exposition, amounting to hundreds of millions of dollars in military hardware, buildings, programs, and subsidies to states, territories, and colonies.

The United States acquired its colonies for commercial gain but in the process, placed the people of its colonies and territories on exhibition as midway(3) attractions and ethnological exhibits, portraying them as primitive people, mere savages in need of the United States' aid and conversion to America's social mores. The bigger the racial slur, the greater the draw. The Filipino people were brought to all of the aforementioned expositions and fairs, where they proved among the most popular exhibits. In fact, after the St. Louis World's Fair, there was not another exposition held in the United States that did not include an extensive Philippine reservation. The same would prove true of the Jamestown Exposition, where the Philippine reservation was one of the largest exhibit areas, its size justified by exposition planners for its entertainment and education value to those paying admission.

The Jamestown Exposition of 1907 grew out of the desire of Virginians, urged by the imperialistic policies of Presidents McKinley and Roosevelt, to rise to the forefront of the spirit and ambition of the country and host "a great International Naval, Industrial and Marine Exposition," an event that would commend itself not only to all parts of the United States, but to the nations of the world. The Virginians gave three reasons that justified the state's holding the exposition: the event which it commemorates, the geographical location in Hampton Roads, and the results the exposition would obtain. The latter explanation of their purpose focused on the fact that every exposition held in the United States, save the one in Philadelphia in 1876, and Chicago in 1894, had been held for solely commercial reasons, but this would not be true of Virginia's effort. Organizers noted that "ours is a wonderful country, and in many respects far surpasses many of those in other parts of the world; yet when a comparison of our patriotism and loyal love for our government, our institutions and past history and achievements is made with some of the older nations, we cannot but admit that our standard is not as high as it should be." What would later be a criticism of the Jamestown Exposition, was one of its strongest attributes: the naval and marine participation, which so lent itself to the waters of Hampton Roads. "This exposition is to be largely a great marine display," wrote the exposition's organizers. "Should the world be at peace in 1907, it is expected that great interest will be taken in making this the most notable gathering of naval vessels ever witnessed. How will it be accomplished? Our own government is already much interested, and naturally so, for the administration feels that much depends upon the constant and gradual increase of our navy." While eager to please the President, exposition officials understood that showcasing the United States Navy would not be supported across the country. In *The Southland* of December 1904, one Virginian noted of the opposition: "A very large portion of people [in the West] can scarcely realize what is done with the vast sums of money provided for in the annual appropriations for a greater navy from year to year and, in fact, it might be said that two-thirds of them have never seen a warship. This celebration is intended to give them this opportunity to the fullest extent, not only to show them the navy of their own country, but that of other great powers as well, and thus demonstrate in an unmistakable manner the need on our part for the building and maintenance of a tonnage to protect ourselves and our coast should necessity arise."

The first time the Jamestown settlement's establishment was celebrated occurred in 1807, its bicentennial. There was another at 250 years, held May 13, 1857, on Jamestown Island. President John Tyler was the guest speaker. In January of 1901, the Virginia General Assembly passed a bill providing the governor the right to declare a tercentennial of the first permanent English settlement in America at Jamestown in 1607. The resolution called upon the cities of Virginia to present their plans for the proper celebration of the event, and for the purpose of commemorating for all the world the real birthplace of the nation. Though the previous celebrations of Jamestown's place in American history were august events, nothing was to compare with plans conceived by James M. Thomson, the one-time owner of the *Norfolk Dispatch* newspaper. In May 1901, Thomson wrote to city councilman John G. Tilton urging Tilton to establish an official committee to explore the idea of hosting the Jamestown Exposition on land available on "Mr. Seawell's Pointe." Thomson's letter arrived only a few short months after Governor James Hoge Tyler (1898–1902) endorsed the general assembly's motion to take bids from municipalities for the honor of holding the exposition. G.T. Sheppard, eventual secretary of the Jamestown Exposition Company, James M. Thomson, and the Honorable John G. Tilton inaugurated a plan and presented it to the city council of Norfolk. Their proposal passed, and they then set about to invite the cities of Portsmouth, Newport News, Hampton, and Norfolk County to join the city of Norfolk in order to make the project a complete success. The celebration had to be a regional effort. Norfolk, with the support of the other cities, secured the event.

Under the direction of Governor Andrew Jackson Montague (1902–1906), the general assembly chartered the Jamestown Exposition Company in 1902. The first president of the company was Major General Fitzhugh Lee, son of Commodore Sydney Smith Lee and nephew

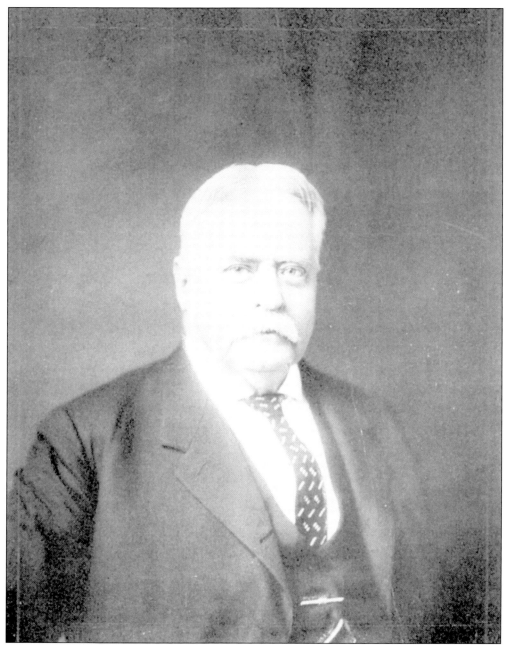

(See inside cover of *The Southland* for picture.) This portrait of Fitzhugh Lee ran in the December 1904 edition of *The Southland*, a monthly magazine devoted to interests of people in the South.

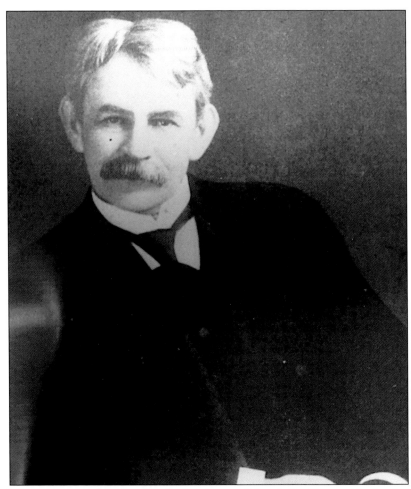

(See p. 1, Jamestown Exposition Bluebook.) Henry (Harry) St. George Tucker became the president of the Jamestown Exposition upon the death of Fitzhugh Lee. Tucker was irrepressible as exposition president, his presence and spirit touching nearly all facets of the planning and execution of the world's fair in Hampton Roads. Tucker, an attorney by trade, was a native of Winchester, Frederick County, Virginia, born on April 5, 1853. The member of a politically popular family, Tucker's path in life was all but clear. The grandson of Henry St. George Tucker (1780–1848) and the son of the Honorable John Randolph Tucker, young Henry, popularly known as Harry, was a natural leader. He graduated from Washington and Lee University, where he received his law degree in 1876, and was admitted to the bar the same year, practicing in Staunton, Virginia. He was a member of the United States House of Representatives, representing the Tenth District, from 1889 to 1897, and 1922 to 1932. In May 1897, Henry was chosen to succeed his father as professor of constitutional law and equity at Washington and Lee University. Tucker was later named dean of the law school there in 1900, and subsequently dean of the school of law and diplomacy at George Washington University in Washington, D.C., in 1905. Prior to being named president of the Jamestown Exposition Company, from 1905 to 1907, Tucker was elected president of the American Bar Association in 1905. Tucker was a popular congressman, his 1922 election stemming from the vacancy in Congress left by the death of Henry D. Flood. He served his last stretch in the United States House of Representatives from the Tenth District until his death in Lexington, Virginia, on July 23, 1932. He is interred at the Stonewall Jackson Memorial Cemetery in Lexington.

of General Robert E. Lee, commander of the Army of the Confederacy. Fitzhugh Lee was appointed a major general on September 3, 1863, and in March 1865, he became commander of the entire cavalry corps of the Army of Northern Virginia. Lee was governor of Virginia from 1886 to 1890 and United States consul general to Havana, Cuba, from 1893 until declaration of war with Spain in 1898. He was appointed a major general in the United States Volunteers, commanding the Seventh Army Corps, that year. Upon cessation of hostilities, President Theodore Roosevelt made Lee the military governor of Havana until January 1, 1899. Fitzhugh Lee was eventually elected president of the Jamestown Exposition Company on September 10, 1902, but passed away shortly after his appointment on April 29, 1905. His successor was the Honorable Henry St. George Tucker, called Harry most of his life to distinguish him from his famous grandfather, for whom he was named.

Henry (Harry) St. George Tucker was initially joined in his effort to raise $1 million toward purchase and preparation of the exposition grounds by 100 citizens of Virginia. Tucker, his fellow officers, and board of governors chose approximately 474 acres of land and 40 acres of water space (between what would later be the arms of the Government Pier) to hold the Jamestown Tercentennial Exposition (hereinafter referred to as the "Jamestown Exposition" or "exposition" unless otherwise noted). The land and water areas used as the fairgrounds would now encompass the majority of land comprising Naval Base Norfolk and its air station, as well as portions of the naval station, land which has been historically and strategically important to the Hampton Roads region since Captain Christopher Newport sailed by in 1607. Hampton Roads' harbor was among the first such anchorages ever seen by the English settlers after they landed at Cape Henry on April 26, 1607, and the land mass today known as Sewell's Point was subject to exploration by Captain John Smith in 1608. Smith's visit led to the first land grant issued on the southside of Lower Tidewater in 1620, to Captain William Tucker, commander of Kecoughtan, later Hampton, where Tucker lived. In a little over a decade's time, three additional land grants were made. By 1635, three significant names in the history of Lower Tidewater would draw land grants on the land that would become so important in the planning and execution of the Jamestown Exposition: Thomas Willoughby, for whom the bay and beach are named north of Naval Air Station Norfolk, Virginia; Francis Mason, for whom Mason's Creek was named; and Henry Seawell, whose name graces the point that came to be known as "Mr. Seawell's Pointe" before 1640. The creek named for Francis Mason was filled in by the United States Navy during a land reclamation project, save a small finger of marsh now crossed by a busy interstate highway.

Upon Henry Seawell's point was built, beginning in 1638, the first parish church in Lower Norfolk County. The site of the first Ye Chappell of Ease was close to today's main gate to Naval Base Norfolk. Construction of the naval base long ago obscured the actual location of the first church of significance in Lower Tidewater.

In June 1901, Norfolk real estate managers recorded a plat for development that extended from Tanner's Creek to Willoughby Bay, including the area on both sides of what we know today as Hampton Boulevard. The Pine Beach Hotel and Pavilion was planned and built in 1902 at the northwest angle of present-day Virginia Avenue and Gilbert Street, its juxtaposition affording hotel patrons a breathtaking view of Norfolk-on-the-Roads. Seawell's, later Sewell's, Point Road was unrecognizable at that time and simply referred to as County Road on turn-of-the-century maps. Maryland Avenue extended from what is now its terminus at Gate 2 of the naval base all the way to the bridge by the Norfolk Yacht and Country Club. At the time of the exposition, the part of Maryland beyond the country club was renamed Jamestown Boulevard. The southern end of Jamestown Boulevard snaked its way through what is now Larchmont to enjoin with the northernmost end of Colley Avenue. The name Jamestown Boulevard was changed to Jamestown Crescent as the Larchmont subdivision developed and Hampton Boulevard was born. All of the exposition's east and west streets were numbered, the highest-numbered street falling closest to the waterfront: 104th Street. Willoughby Boulevard eventually gave way to the name Dillingham Boulevard once the United States Navy acquired the property in 1917.

Taussig Boulevard was Ninety-ninth Street, and Ninetieth Street was, and is, the entrance to Fleet Recreation Park off present-day Hampton Boulevard. The rail lines of the Norfolk & Atlantic Terminal Electric Railroad crept close to Maryland Avenue. The railroad maintained a wide turnaround circle at its northern drop-off point, and a spur of its track also went to the pier and boat landing at the west end of Ninety-ninth Street (Taussig Boulevard), this being the landing area for ferries bearing visitors moving to and from the exposition from the Virginia Peninsula. The ferry was called the Pine Beach Ferry, even after the exposition and before the Hampton Roads Bridge-Tunnel system came into being. The Norfolk & Atlantic's electric car line later became part of the Virginia Railway & Power Company system, which terminated in downtown Norfolk at Atlantic Street.

The exposition stretched from Maryland Avenue on the west to Boush Creek, subsequently filled in by the Navy, about half a mile east of present-day Bainbridge Boulevard, and from Willoughby Boulevard (now Dillingham), which was then the waterfront, to Ninety-ninth or Algonquin Street, presently Taussig Boulevard.

Exposition buildings were divided into three distinct categories: exhibits, state buildings, and amusements. The exhibit buildings were devoted to such subjects as transportation, machinery, manufacturing, mines and metallurgy, liberal arts, education, history, social economy, government, and so on, while the state buildings showcased the contributions of 21 states, 2 cities (Baltimore, Maryland, and Richmond, Virginia), Alaska, Panama, Puerto Rico, Cuba, and the Dominican Republic. The state buildings were located along the waterfront as well as east and west of the exhibit palaces. Amusements, called the War Path, were located on both sides of present-day Gilbert Street between Bacon Street and Commonwealth Avenue (now Farragut Avenue). The War Path resembled a carnival midway and featured attractions such as the "Battle of Gettysburg"; "Colonial Virginia"; "Battle of the Merrimac [sic] & Monitor"; "San Francisco Fire"; "Temple of Mirth"; and "Shooting the Chutes." There was also the ever-popular Miller Brothers 101 Ranch Wild West Show. The Inside Inn, where today's Naval Station Norfolk bachelor officers' quarters is situated on the east side of the north end of Maryland Avenue, was named Inside Inn because it was found inside the exposition grounds, while the Pine Beach Hotel was outside the grounds.

The Jamestown Exposition Company failed to secure funding from the United States Congress until June of 1906, at which time a rider on the Sundry Civil Appropriation Bill provided, according to government documentation, $200,000 for government personnel, $350,000 toward the erection of buildings, and $400,000 for the construction of a majestic, brilliantly lit pier, now the site of the Navy's Special Service Marina. Invitations were sent to all the states requesting participation in the exposition. Only 21 of those replied and offered plans to build state buildings. Company officials chose Colonial Revival architecture to ensure uniformity of all the buildings.

The Jamestown Exposition Company authorized clearance of the grounds at Sewell's Point from the northern end of Sewell's Point Road, known as Maryland Avenue, to Boush Creek, an area which has since been filled in. The creek, it is interesting to remark, used to flow through the former Naval Aviation Depot Norfolk's facilities. The water's edge, north of what is now Dillingham Boulevard, was the northern boundary of an area that ultimately extended south of what is today Taussig Boulevard. To accommodate the company, the Pine Beach Development Corporation leased acreage west of Maryland Avenue to the exposition organizers. The company could probably have done just as well without the additional land from the Pine Beach syndicate. Pine Beach had become the site of some of the worst gambling houses in Norfolk, though ever-popular. Having such tawdry syndicate property abutting the exposition grounds was thought to have negatively tainted the atmosphere of the entire event.

Due to unforeseen delays, many of the state buildings and main exposition quarters were unfinished when the Jamestown Exposition opened at noon on April 26, 1907, 300 years to the day after the landing of Christopher Newport and his three small ships at Cape Henry, the first landing of the future British colonists in America. There was a great deal of hoopla as a state's

day came up and the house was near completion. Each state wanted its display of patriotism and culture to outshine all the others. Competition between states made many of the exhibits all the better for exposition patrons.

The first week of the exposition saw foreign dignitaries, royalty, and men of outstanding international business and literary prominence alight on the grounds. There were representatives from Great Britain, France, Italy, Holland, Japan, Switzerland, Cuba, the Philippines, Austria-Hungary, Sweden, and Norway. Great Britain, Germany, Russia, France, Japan, Italy, Denmark, Venezuela, Mexico, Costa Rica, Haiti, Japan, Argentina, the Dominican Republic, Belgium, Brazil, and Chile sent ships and troops to join the American fleet assembled in Hampton Roads. There would be exhibits by Mexico, Haiti, the Philippines, Siam (Thailand), Japan, and Puerto Rico, among others. The nations of Persia (Iran), Russia, and China agreed to participate in the exposition in some way. The Jamestown Exposition Company had wanted the event to reach prominence of national proportions. They succeeded.

There were a number of company-constructed buildings including the Auditorium, States' Exhibit Palace, Palace of Manufactures and Liberal Arts, and Mines and Metallurgy Building. All were built in the Colonial Revival style. The Mothers and Children Building, Arts and Crafts Village, and the Pocahontas Hospital were, according to exposition records, constructed in Beaux Arts style. In keeping with the natural vegetation, or that which was indigenous to Virginia, the company planted giant paulonia, willow oaks, hornbeam, persimmon, red maples, paper mulberry, magnolias, and dogwoods. Each street had a unique landscape of herbs and flowers. Among some of the most lovely and fragrant of the plantings were walls of honeysuckle, trumpet vine, and crimson rambler roses, which went around fences on the grounds. To establish a sense of place and the flavor of the celebration, the exposition grounds were designed like a town with a municipal center represented by the Auditorium, which faced out in Hampton Roads harbor. The Grand Basin in front of the Auditorium had two long piers, one named Godspeed and the other the Susan Constant, representing two of the original Jamestown ships.

1. Thomas Moore's beautiful lines in the acknowledgments come from *Believe me, if all those endearing young Charms*.
2. Masters, Edgar Lee. "Theodore Roosevelt," *The New Star Chamber and Other Essays* (Chicago: Hammersmark Publishing Company, 1904).
3. The term "midway" originated at the Columbian Exposition of 1893 in Chicago, Illinois. The Midway Plaisance, site of the exposition's amusements, coined the term used to describe any avenue at a carnival, fair, exposition, or permanent amusement park used for concessions and amusements. Though the Filipinos were not placed on the War Path at the Jamestown Exposition, or along the typical midway at any of the other expositions, their presence and promotion at these events was the same as being touted as a carnival attraction.

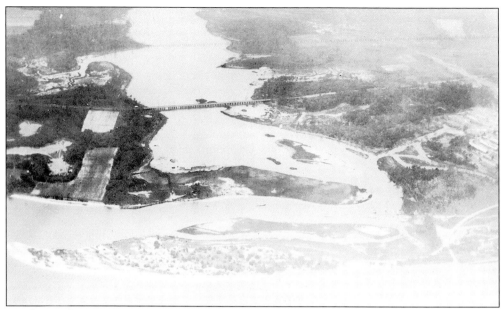

Boush Creek was photographed by Frank J. Conway c. 1916, the Jamestown Exposition statehouses barely visible to the right. In the photograph below the appendage of land at the head of Boush Creek was filled with aircraft hangars and seaplanes, part of the United States Navy's expansion onto the land mass. This picture was taken approximately 1920. The greater portion of Boush Creek was eventually filled by the Navy, save a small portion.

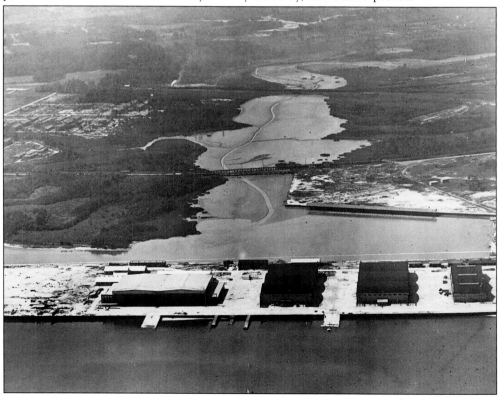

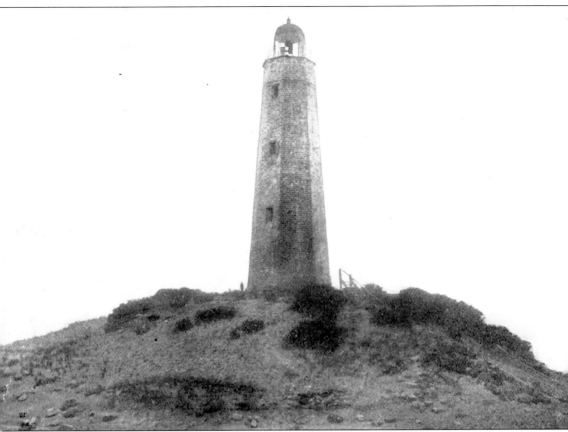

Before alighting at Jamestown, Captain Christopher Newport and his band of colonists first landed at Cape Henry on April 26, 1607, where they raised a wooden cross and named the place in honor of Henry, the Prince of Wales. Though they were soon driven off by Chesapeake Indians, the English proceeded to Hampton Roads and anchored at a sheltered place, which they named Point Comfort. From there, they sailed directly to Jamestown, where Newport and the others established the first permanent English settlement in the United States. The old Cape Henry lighthouse, shown here, c. 1907, was built in 1791, on the historic site of the first landing, though it was not fully in operation until the following year.

One

Birthplace of a Nation and a Native American Princess

"Come friends and merry gentlemen,
 Let nothing you appal;
From Dartmouth moor, from Lincoln's fen
 Hark to the New World's call;

Staunch ships are riding in the bay,
Stout hearts are needed for the fray,
Who'll let the Spaniard say us nay?
 Then courage one and all!"

—From "Song of the Adventurers," *Virginia*, 1907
Mrs. James P. Andrews, of Hartford, Connecticut

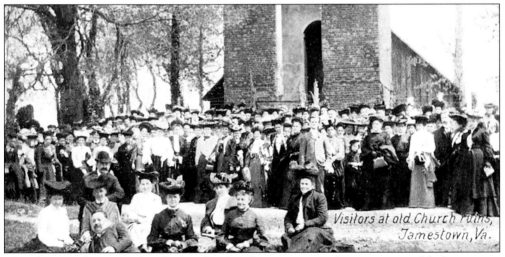

This photographic image, hand colored and made into a postcard, is a rare view of the Jamestown Church. The ladies, with a few men interspersed, belonged to the National Society of Colonial Dames of America, who raised the necessary funding to build a new church on Jamestown Island, constructed upon the old foundations. Though the church was finished on April 11, and officially turned over to the Association for the Preservation of Virginia Antiquities (APVA), Colonial Dames gathered on the island on May 11, 1907, the occasion for this picture, to ceremoniously present the new edifice to the Association for the Preservation of Virginia Antiquities. Two days later, on May 13, APVA dedicated the new church in celebration of Jamestown Day at the exposition. The postcard was printed in Germany for I. Stern, of New York.

The Jamestown Exposition took North American history to its roots. The discovery of the New World by Columbus in 1492 compelled the event's organizers to include wood-cut and lithographic images of the nation's pre-English past. (Harry C. Mann, photographer.)

Young Elliot Braxton, a sixth-grade student from Hampton, had his artwork exhibited at the Jamestown Exposition as part of Hampton and Elizabeth City County display. Braxton drew this image of a medieval archerer titled, "The Ways of the Bow and Arrow." When the Virginia Public Schools requested contributions from around the commonwealth, each school system submitted rather sophisticated exhibitions of their children's school work. (Courtesy of the City of Hampton.)

Birthplace of a Nation

Jamestown as birthplace of a nation holds many firsts in American and Virginia history, though not all of them are as widely recognized as others. The Jamestown story began several years before letters of patent were issued for colonization. Bartholomew Gosnold, the financial doyen behind the London Company, had made an exploratory voyage to New England in 1602, but the experience galvanized Gosnold to return to the New World as part of a colonization effort. He made repeated requests to return to the New World to explore southward, his efforts rebuffed until Gosnold met adventurer Captain John Smith. Historian Charles Campbell wrote in 1847, that "Gosnold was the prime mover, and Captain John Smith the chief actor in the settlement of Virginia." Gosnold became acquainted with Smith, but also Edward Maria Wingfield, a merchant, and Robert Hunt, a clergyman, who aided him in his effort. King James I gladly supported Gosnold and Smith's plan to establish a permanent English settlement.

On April 10, 1606, letters of patent were issued authorizing two colonies to be established in Virginia, which, at that time, was all land from 34 to 45 degrees north latitude. There would be one colony to the north and one to the south. The southern colony was to be overseen by the London Company. The vessels that left Blackwall, England, for the New World, *Godspeed*, *Discovery*, and *Susan Constant*, were under the command of Captain Christopher Newport, a navigator already experienced in voyages to America. In his possession at the time of departure from England was a sealed box containing the expedition's orders upon reaching landfall in

This was postcard No. 2 in the series of official souvenir postcards printed by the Jamestown Amusement & Vending Company for the exposition. The colonists departing England for the New World was the subject of the postcard. On the back reads, in part, "They at once prepared to send out a colony, and on December 19, 1606, 105 men listed as gentlemen, carpenters, and laborers (but 12 were laborers) set sail down the Thames in the 'Susan Constant' of 100 tons, the 'Godspeed' of 40 tons and the 'Discovery' of 20 tons, or as some authorities state, the 'Sarah Constant,' " under the command of "Admiral Christopher Newport. After a very long, tempestuous and eventful voyage they passed through the Virginia Capes late in April, 1607, touched at Cape Henry, Point Comfort, Hampton and other points, and finally landed and settled at Jamestown, May 13, 1607."

Virginia. The fleet was delayed for almost six weeks by a strong head-wind off the English coast. Newport would eventually proceed along the old trade route by way of the Canaries to the West Indies, and after three weeks, sailed for Roanoke Island. The ships, however, exceeded their reckoning by three days, failed to spot land, and one of the ships' captains, John Ratcliffe, requested Newport's permission to turn back for England. Before Ratcliffe's request could be answered, a terrible storm kicked up and drove the voyagers into the mouth of the Chesapeake Bay. The expedition came in site of what is known today as Cape Henry on April 26, 1607, and named the land mass in honor of Henry, the Prince of Wales, eldest son of King James I. Once ashore, Newport's landing party of 30 men found "flowers of divers [sic] kinds and colors and goodly trees." They also encountered a bit of trouble. Warriors from the Chesapeake tribe attacked the Englishmen under cover of darkness. Captain George Percy described two of their party being wounded, one by the name of Matthew Morton, seriously. Percy recorded, "We came to a place where they had made a great fire, and had been newly roasting oysters. When they perceived our coming, they fled away to the mountains, and left many of the oysters in the fire. We ate some of the oysters, which were very large and delicate in taste." The mountains to which Percy refers were the Antaean tree-covered sand dunes that rose nearly a hundred feet high at Cape Henry.

After their departure from Cape Henry, and a brief stay near Old Point Comfort, Newport proceeded to their settlement point: Jamestown. In accordance with their instructions, Newport, Gosnold, Smith, and Wingfield opened the sealed box. In it were instructions for them to establish a council, the new government to oversee colonial expansion in Virginia. The date was May 13, and as the first 105 male settlers arrived off their ships at James Cittie, they established not only the first English settlement in the New World but the first capital of Virginia. Members of the first council were Edward Maria Wingfield, also elected its first president, Captain John Smith, Bartholomew Gosnold, Captain John Ratcliffe, John Martin, and George Kendall. Within five months, Wingfield would be removed as president after being found guilty of libel. Smith eventually replaced Wingfield as president of the council, but Wingfield was not the only troubled council member. Kendall was convicted of causing discord

The landing at Jamestown on May 13, 1607, was the subject of postcard No. 3 in the official souvenir series.

in the colony and later executed. By January 1608, the king sent a replacement to serve on the council, Matthew Scrivner (also Scrivener).

As the Jamestown settlement built shelters, James Fort, and a church in 1607, the colony also established the first Anglican church—of Episcopal faith—in North America, and as a result, the first English celebration of Christmas in the New World was held that December. The list of firsts recorded by Jamestown set the stage for the legislative form of government we know today. The first meeting of the Virginia House of Burgesses, the beginning of representative legislative government in the New World, occurred on July 30, 1619. The Virginia General Assembly remains the oldest continuous legislative body in America.

Twelve years after its establishment, Jamestown colonists, all men up to that point, had 90 women sent from England to Virginia to make wives for their suitable young men. In return for a wife, the men paid the Virginia Company prices per woman fixed at "one hundredth and fiftie [pounds] of the best leafe Tobacco." At the end of August 1619, a Dutch ship and an English ship (recorded as the *Treasurer*) raided Spanish slave ships, one of which was the *San Juan Bautista*, off the coast of Campeche and captured their human cargo. The Dutch man-o-war, name unknown, arrived at Point Comfort, located near today's Hampton and Fortress Monroe, where they proceeded up the James River to Jamestown. Her master sold the 20 Africans, natives of Angola, a Portuguese colony, as indentured servants to Governor Sir George Yeardley and Abraham Piersey, the wealthiest merchant residing in the colony. Portuguese merchants headquartered at Sao Paulo de Loanda, the modern-day city of Luanda, capital of Angola, were more than willing to oblige their cohorts in Spain with a steady supply of African slaves for Spanish South American markets. Slave trade between Africa and South America was a thriving business, while African slave trade to the New World can be said to have begun with this unnamed Dutch corsair. Indentured servants were initially satisfactory labor to tend to ever-growing tobacco crops, but soon, Virginia's major cash crop would require more field workers than indentured servants could provide, hence the Virginia colony fast became a major importer of African slaves, no longer given the indentured option. It should be noted, however, that when the *Treasurer* tried to deposit its stolen human cargo, also taken off the *San Juan Bautista*, the English corsair was not permitted to sell or trade the Angolans. The Angolans were taken to Bermuda instead, where they were sold as slaves.

The firsts at Jamestown included cultural and social steps forward as years passed, and the settlement achieved royal colony status in 1625. The first distillation of corn whiskey and the first cultivation of tobacco as a cash crop, and the first printing press in America, in 1682, all occurred at Jamestown. The printing press had a short life-span, because the royal governor did not like what the printer was printing and banned both the press and printer, who smartly fled to Maryland. After numerous and savage attacks by Native Americans, an insurrection led by Nathaniel Bacon in 1676, bouts of pestilence and devastating fires, Jamestown was finally abandoned as the colonial capital in 1699 in favor of Williamsburg. Little was left of the island community that gave birth to a nation.

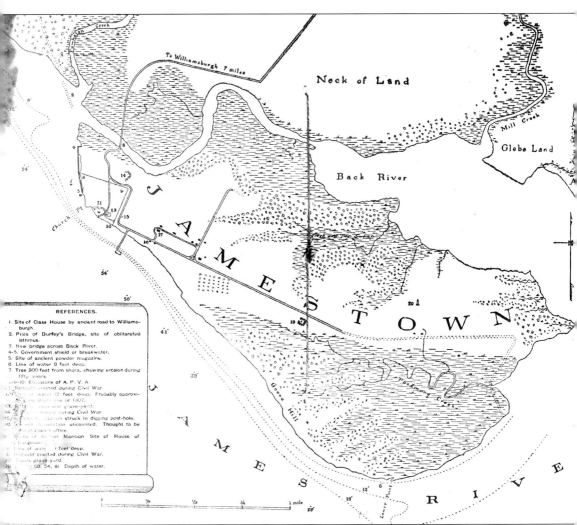

This map of the Jamestown settlement was drawn by E.H. Hall in 1903. The legend for the map is as follows: 1) Site of Glass House by ancient road to Williamsburgh [sic]; 2) Piles of Durfey's Bridge, site of obliterated isthmus; 3) new bridge across Back River; 4 & 5) Government shield of breakwater; 6) Line of water 6 feet deep; 7) Tree 300 feet from shore, showing erosion during 50 years; 8, 9, & 10) Enclosure of Association for the Preservation of Virginia Antiquities; 11) Redoubt erected during Civil War; 12) Line of water 12 feet deep. Probably approximately showing shore line of 1607; 13) Church tower and grave-yard [sic]; 14) Redoubt erected during Civil War; 15) Ancient foundation struck in digging post-hole; 16) Ancient foundation uncovered. Thought to be the site of Clerk's Office; 17) Ruins of Ambler Mansion and Site of House of Burgesses; 18) Line of water (illegible) feet deep; 19) Redoubt erected during Civil War; and 20) Travis grave-yard [sic].

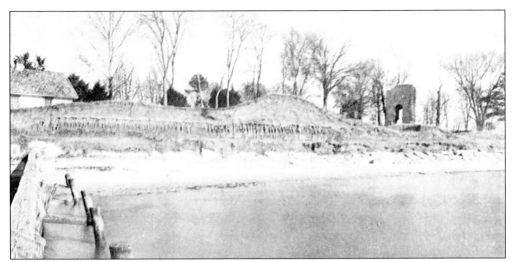

Though this postcard is titled "Jamestown in 1907," and is No. 18 in the official Jamestown Exposition postcard series, the image from which the postcard was produced was likely taken about 1905. Jamestown was a peninsula at the time of the landing on May 13, 1607, but had become an island, which would have gradually eroded away if the United States government had not erected a breakwater, not visible on the postcard.

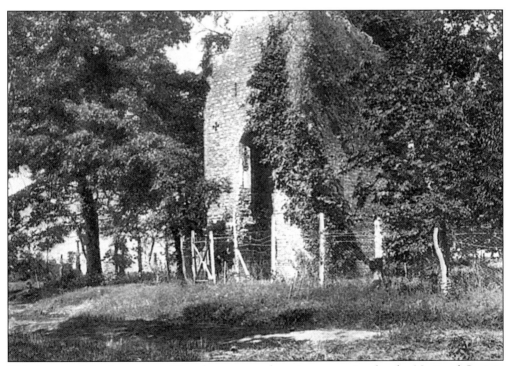

This image of the Jamestown Church tower predates its restoration by the National Society of the Colonial Dames of America in 1907. The postcard, an undivided back c. 1901, was No. 625 in a series made by Tucker, Hall & Traylor, of Germany. The company printed some of the finest postcards in the world at that time, and this one is no exception. Considered rare, the card is hand colored in fine earthen hues.

The Association for the Preservation of Virginia Antiquities (APVA), established in the 1880s, acquired 22.5 acres of the island in 1893. A seawall was erected by the United States government in 1901-02 along the southwest point to halt further erosion. This breakwater, built of concrete blocks, protected the site of old Jamestown (within the APVA enclosure) from further erosion by the James River. Colonel Samuel H. Yonge, of Richmond, an historian and archaeologist for the APVA, was the constructing engineer under the United States War Department. It was Yonge who discovered and identified foundations of the third and fourth statehouses and further identified a five-in-one bottom foundation in 1903 (see page 27). The National Society of the Colonial Dames of America built a memorial church on the foundations of the first brick church in 1907, the year of the Jamestown Exposition. Jamestown Island was designated a National Historic Register site in 1940, at which time APVA made a joint agreement with the Department of the Interior to develop Jamestown Island and properly study it. The Jamestown Exposition of 1907 drew extraordinary national attention to Jamestown Island, and to its preservation. This panoramic view of the Jamestown Island waterfront from the wharf, taken c. 1907, by Harry C. Mann, provides perspective in terms of monuments and placement of significant landmarks on the site. The obelisk visible on the far right was erected by the United States government at Jamestown Island in honor of Jamestown as America's birthplace.

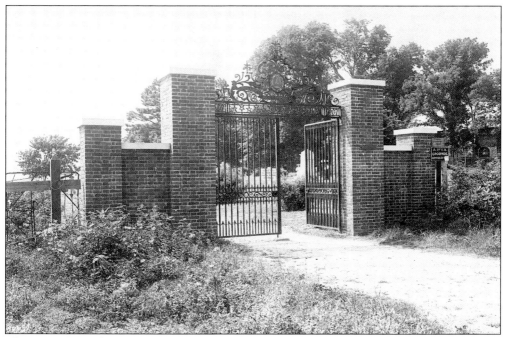

The magnificent bronze gate presented by the National Society of the Colonial Dames of America at Jamestown Island on April 9, 1907, marked the entrance to APVA's property. The gates, as well as most of the additional landmarks shown on these pages, are visible in the panoramic photograph, shown above, by Harry C. Mann, c. 1907.

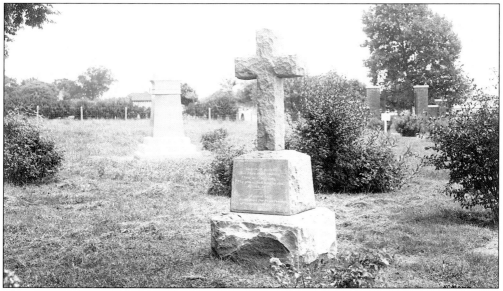

The Pious Pilgrimage Monument commemorates the visit on October 15, 1898, of 300 Episcopal bishops and clergymen from a convention in Washington, D.C., to the then deserted and desolate Jamestown Island. The monument was photographed by Harry C. Mann, c. 1907, as part of a series of historic pictures Mann would take of Virginia's prize historic sites around the commonwealth. The monument takes a few lines from Psalm 102, lines 26 and 27: "They shall perish / but Thou shalt endure; / Thou art the same / Thy years shall have no end."

The National Society of the Colonial Dames of America was a valued contributor to the restoration of Jamestown Island and to the subsequent Jamestown Exposition of 1907. National president of the Colonial Dames, Penelope Bradford Battle Cox, wife of William Ruffin Cox, is pictured here, some years before the exposition. Penelope Battle married a hero of the South. William Ruffin Cox was born on March 11, 1831, in Scotland Neck, Halifax County, North Carolina. During the Civil War, Cox rose to the rank of brigadier general on the side of the Confederate army. He was wounded 11 times during the war, including the Battle of Chancellorsville. Though Cox served in a variety of judicial and state offices, he would be elected to the United States House of Representatives from the Fourth District of North Carolina in 1881, remaining in office until 1887. William Ruffin Cox was subsequently elected the secretary of the United States Senate on April 6, 1893, and served in that role until January 31, 1900. He died on December 26, 1919, while visiting in Richmond, Virginia, and is buried at Oakwood Cemetery in Raleigh, North Carolina.

Captain John Smith, president of the local council at Jamestown, 1608, was honored with a monument naming him "Governor of Virginia." Sculptor William Couper is responsible for the bronze statue to Captain John Smith, located near the Pocahontas sculpture. Harry C. Mann took the photograph in 1907, at Jamestown Island. The statue, standing on a granite pedestal, was the gift of Mr. and Mrs. Joseph Bryan, of Richmond, Virginia, to the APVA, and erected in 1907.

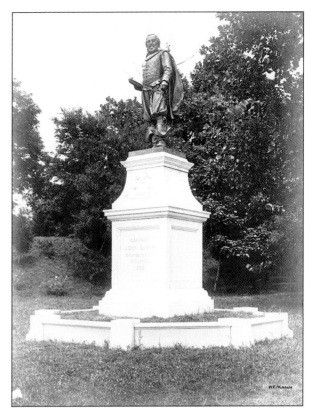

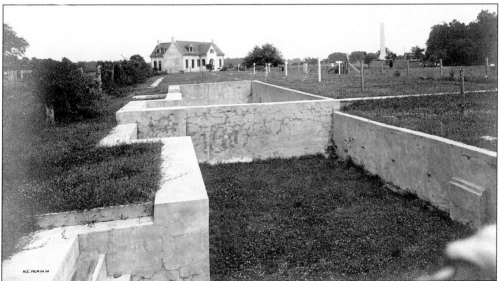

The foundations of old statehouses are visible in the foreground of this Harry C. Mann photograph, taken c. 1907, at Jamestown Island. The Daughters of the American Revolution (DAR) Building and government monument are in the background. The partnership between APVA and the National Park Service led to important early archaeological excavation on the island. The foundations of Virginia's first statehouse, as well as the foundations of the third and fourth statehouses, were believed found.

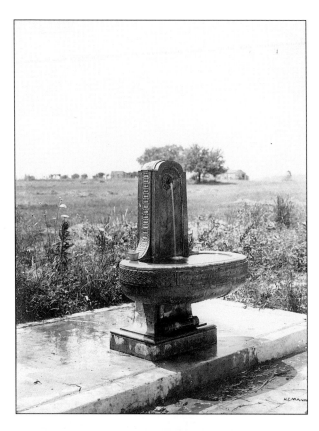

The outdoor pump and fountain, shown here c. 1907, was presented by the Society of Colonial Wars to APVA, probably around the turn of the century, and is located at APVA's Jamestown site. This was one of several old wells dug by the early settlers and located between the old statehouse site and the Yeardley House, a replica in semblance of Hays-Barton, the birthplace of Sir Walter Raleigh, and named in honor of Sir George Yeardley. The curbing around the pump is a modern addition. (Harry C. Mann, photographer.)

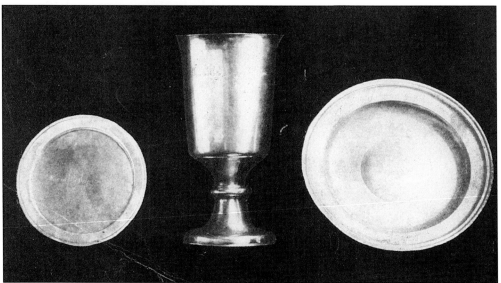

The Jamestown communion service, shown here, was in the possession of Bruton Parish Church in Williamsburg, Virginia, when this photograph was taken in 1906. An inscription on the chalice reads as follows: "Mixe not holy thinges with profane." The chalice also bears the date 1661. The communion service was used by Bruton Parish from the time the colonists abandoned Jamestown until such a time that it was placed in curatorial care.

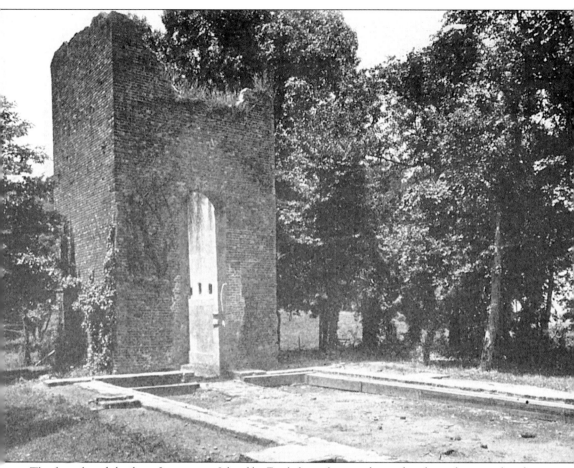

The first church built on Jamestown Island by English settlers was burned within a few months of its completion, and four others followed it successively. The fourth, the tower of which was left standing and is shown here, was built c. 1640 and burned during the peak of Bacon's Rebellion in 1676 by Bacon's own hand. Though it was rebuilt, the tower and foundation, visible in this photograph taken c. 1905, were all that remained when the Colonial Dames began their construction of a new edifice. The churches that stood on Jamestown Island represented many firsts in America's history. The first English marriage on American soil, between John Laydon and Anne Burras, occurred in 1608, soon followed by the first baptism, Virginia Laydon, in 1609. The marriage of Matoaka (Pocahontas) to John Rolfe took place in 1614, the union of the first Euro-American with a Native American in the sanctity of a church. In the old chancel are two tombs, the first is thought to be that of Sir George Yeardley, four times governor, and the other of Reverend John Clough. Graves beneath the brick floor are located by blocks of white marble.

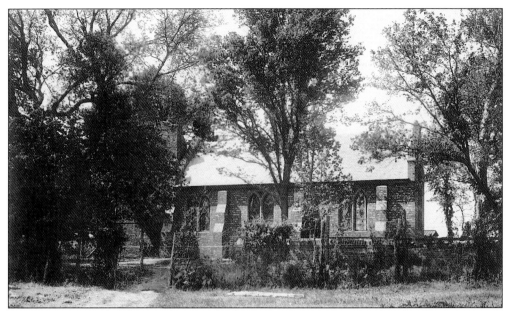

The Jamestown Church was photographed by Harry C. Mann immediately after restoration in 1907, its grounds still bearing the signs of the church's long abandonment. The tombs of Dr. James Blair and his wife, Sarah Hamilton, were originally only 10 inches apart, but were subsequently enveloped, broken, and separated by a large sycamore tree that grew between them, sometime after 1743. The Blairs' graves were restored about 1906.

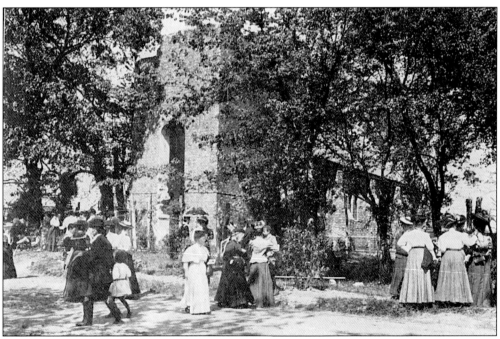

Members of the National Society of Colonial Dames of America returned to Jamestown Island on May 13, 1907, for the dedication of the new church in celebration of the Jamestown Exposition.

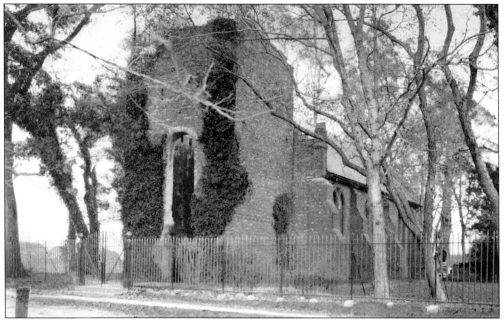

The Albertype Company, Brooklyn, New York, marketed this hand-colored postcard of the Jamestown Church. The postcard was published by B.E. Steel, Jamestown Island, Virginia, c. 1910. When the church was burned during Bacon's Rebellion, the old church tower was nearly all that remained of the original structure. The church erected by the colonists after the rebellion was used until 1758.

The Naughty One

The story of Pocahontas should begin with an explication of her name. Pocahontas was only a nickname, not her real name: Matoaka. Matoaka was teasingly called Pocahontas by her people, meaning "the naughty one," "spoiled child," and some interpretations have even suggested the name indicates "frolicsome." Unfortunately, it is a nickname that Euro-Americans adopted as her name for the history books, and Jamestown Exposition planners used liberally on street names and exhibitry.

Matoaka, hereinafter referred to as Pocahontas unless otherwise indicated, was born in 1595 in Werowocomoco, located on the north side of the Pamaunkey River, now the York River, 25 miles below where the river divided at West Point, in Gloucester County. She was the eldest daughter of Powhatan (155?–1618), chief of the Powhatan Confederacy of Tidewater Algonquian tribes, numbering some 7,500 people from 30 tribes. Though Powhatan was known to have several wives and as many as 20 sons and 10 daughters, Matoaka was his favorite, but as a result of Powhatan's playing favorites, she was tagged with the nickname that was to identify her for all time: Pocahontas.

Pocahontas was approximately 12 years old when English settlers came to Powhatan's lands and established the settlement on a peninsula, now an island, they named Jamestown. Though she had passing contact with Captain John Smith, and was, by most accounts, fascinated by the original 105 English settlers who came to Jamestown, the incident in which she purportedly saved Smith from being executed by her father has never been proven to have ever occurred, at least as Smith told it many years after his staged execution was to have occurred. Smith never mentions Pocahontas in his writings in the context of "saving" him until 17 years after it supposedly happened, leading to supposition that he created the story to romanticize his role

among the native peoples of Virginia. This would not have been out of character for Smith, who enjoyed aggrandizement of his exploits, particularly with women. Whether Pocahontas and Smith could be called friends has been a controversial aspect of the Powhatan princess's life as historians have sought to unravel the true nature of the relationship. Her life story is riddled by many fabled stories and legends, of which the Smith chapter is the most famous.

During the administration of Sir Thomas Dale, the Virginia colony's High Marshal, pronounced "a rough soldier" by contemporary historians, Pocahontas was taken from a Powhatan warrior named Japazaws by Captain Samuel Argall as she was on a social visit near the Potomac River in 1612. Pocahontas was spirited away to Jamestown, where she had not been since Captain John Smith departed for England and her father had ordered the massacre of Jamestown's 60 surviving settlers visiting Werowocomoco in the fall of 1609. Held as a pawn in the war between the English settlers and Chief Powhatan, Pocahontas lived peaceably among the English at Jamestown in the home of a Protestant minister named Alexander Whittacker. Under Whittacker's care, she converted to Christianity and was baptized at Bermuda Hundred on the south side of the James River, not far from Henrico, in 1614. Her Christian name was Rebecca, and from that time on, Rebecca was the name everyone called her.

While living in the settlement, Pocahontas met a 28-year-old widower named John Rolfe, a tobacco merchant. Rolfe's first wife had died shortly after their arrival at Jamestown from Bermuda, and he had become increasingly attracted to Pocahontas. Rolfe was so taken with her, he ultimately secured Powhatan's permission to marry his eldest daughter. The marriage was performed in the church at Jamestown, about April 5, 1614, and was the first recorded marriage between a white man and a Native American in the New World. When Dale left Virginia in June 1616, he took with him to England, John Rolfe and his wife, now the Lady Rebecca, and their infant son, Thomas. Thomas had been born in 1615 in a house built on land about 40 miles north of Jamestown, the land having been a wedding gift from Powhatan to his daughter and her new husband. Descendants of Rebecca and John Rolfe were known as the "Red Rolfes," Thomas having been born with his mother's distinct Native American features. Much of Rolfe's motivation in taking his Native American princess to England was to help promote his interests in Virginia tobacco through the Virginia Company of London.

John Rolfe, Rebecca, and young Thomas set off for Virginia in March of 1617, but Rebecca fell ill, possibly of a respiratory infection induced by the damp English weather and months of breathing smoke from London's coal fires, and had to be taken off the ship at Gravesend, England. She expired there on March 21, at the age of 21. Powhatan's eldest daughter was laid to rest at Gravesend. Shortly after her funeral, Rolfe was informed that Thomas was too fragile to make the trip to Virginia, so Rolfe left him with an uncle. Chief Powhatan died the following spring of 1618, some would estimate in excess of 80 years of age.

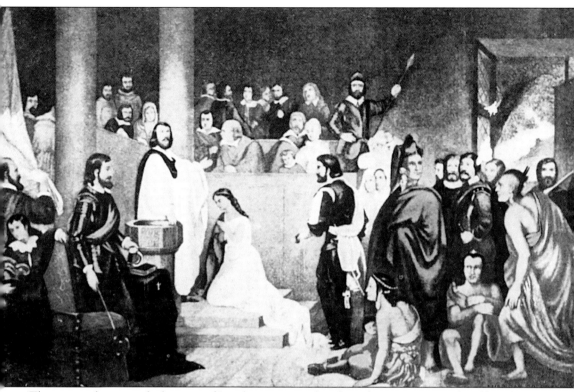

This image, depicting the baptism of Pocahontas, was taken from the painting completed by John Chapman in 1840, which now hangs in the Rotunda of the United States Capitol. Chapman's image clearly reflects Pocahontas' appeal as an American cultural icon. The painting was finished at a time when America's political and military leadership wrestled with the issue of the place Native Americans would—or clearly would not—have in the culture of this country, according to the thinking of white Americans in the mid-nineteenth century. Chapman's work softens the image of Native Americans, invoking Euro-American religious symbolism to build commonality between divergent races. The minister, Alexander Whittacker, Pocahontas, and John Rolfe are bathed in divine light, a European Renaissance painting tradition that suggested holy benediction. Chapman anglicized her features, connoting an even Virgin Mary resemblance in his rendering of America's Indian princess. It should be noted that there are two significant Native Americans in the painting as well. The first is Opechankanough, Pocahontas' uncle, and the other is Nantequaus, the warrior who would later execute Powhatan's order to massacre the Jamestown settlement. Opechankanough skulks in the shadows of the painting, ignoring the baptism of his niece, while Nantequaus turns away, the plumage on his head-dress rising over the heads of those assembled to witness the event. Chapman's point is easily understood: Pocahontas symbolized acceptance of English ways, while her native people, by a white man's standard, rejected the grace of God before them. Pocahontas had become the epitomé of the "noble savage" pitted against the idea of "unassimilated savages" and treacherous behavior, differences which Euro-Americans were not soon to forget as they expanded westward in the 1840s. The font used for the baptism is said to have been the one in Bruton Parish Church in Williamsburg.

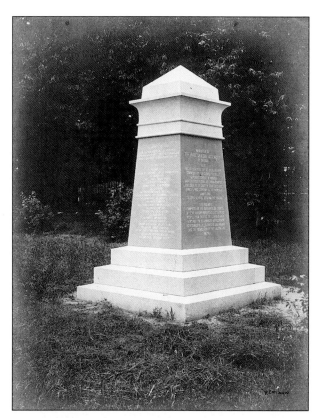

This monument was dedicated to the first General Assembly of Virginia at Jamestown Island, and photographed by Harry C. Mann, c. 1907. The first meeting of the Virginia House of Burgesses took place on July 30, 1619, signifying the beginning of representative legislative government in the New World. Between July 30 and August 4, the Virginia General Assembly met in the choir of the Jamestown church, its chief outcome being passage of Virginia's first law requiring that tobacco be sold for at least three shillings per pound. The monument was given by the Norfolk chapter of the APVA on July 31, 1907, as a lasting memorial to the first House of Burgesses. This governing body antedated all other colonial representative assemblies in colonial America.

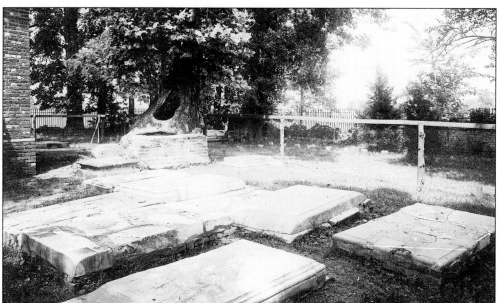

By the end of the nineteenth century, the only remaining structures on Jamestown Island were the c. 1640 brick tower of the church, a series of Confederate earthwork fortifications, and the ruins of the eighteenth-century Jaquelin Ambler mansion. These tombs on Jamestown Island were located near the old Jamestown church. Harry C. Mann photographed them in 1907.

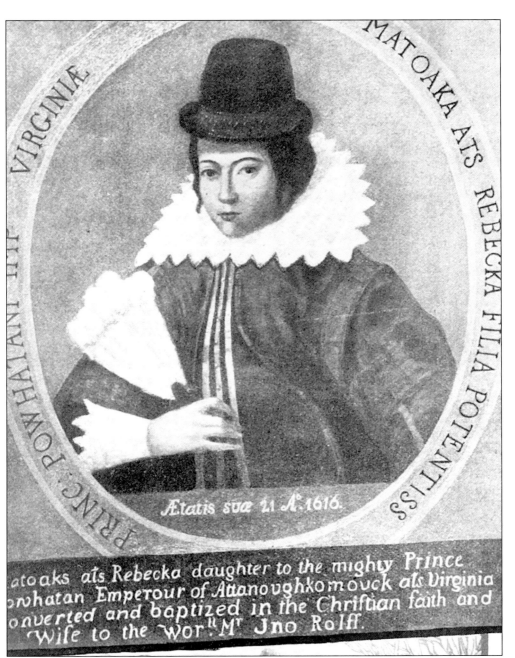

Pocahontas as Lady Rebecca Rolfe received much attention in London social circles. This image was taken from a painting originally housed in the Royal Art Gallery, London. The image was copied by W.L. Sheppard from the original found in Barton Rectory, Norfolk, England. This copy of a copy is taken from the original Simon Van de Passe engraving, which exhibited more of Pocahontas' Native American features than the anglicized version shown here, probably rendered much later. Simon Van de Passe, the 21-year-old son of a famous Dutch engraver, did Pocahontas' portrait on copper plate sometime while she was staying in London. The engraving is the only known life portrait of Pocahontas, and the oldest portrait in the National Portrait Gallery collection in Washington, D.C.

This oil-on-canvas painting of an anglicized Pocahontas was exhibited at the Jamestown Exposition, where the photograph was taken by Harry C. Mann in 1907. The artist was Richard N. Brooke.

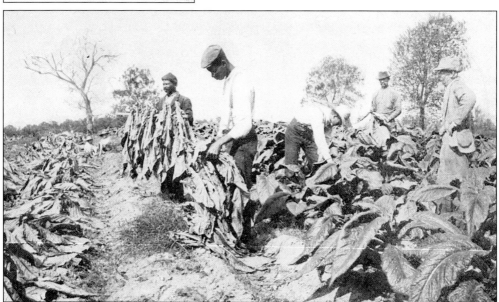

Tobacco became Virginia's legal tender in 1642 as colonials measured their wealth in the number of processed hogsheads of tobacco, called "brown gold." Colonial clergy received their salary in so many pounds of "sweet Virginia." The picture shown here was taken c. 1900 of workers bringing in tobacco from a field in western Lower Tidewater. The photographer is unknown.

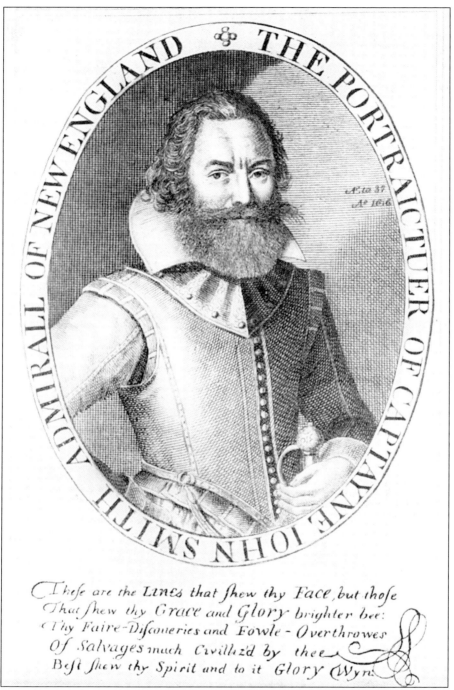

Captain John Smith was born at Willoughby, England, January 15, 1580, and died June 21, 1631, at the age of 51. He is buried at St. Sepulchre's Church, London, England. Smith accompanied Sir Thomas Gates' expedition for the New World, December 1606, arrived at Chesapeake Bay on April 26, 1607, and anchored at the Jamestown site on May 13, 1607. He well may be called the founder of America. This image of Smith is from a 1616 engraving by Simon Van de Passe.

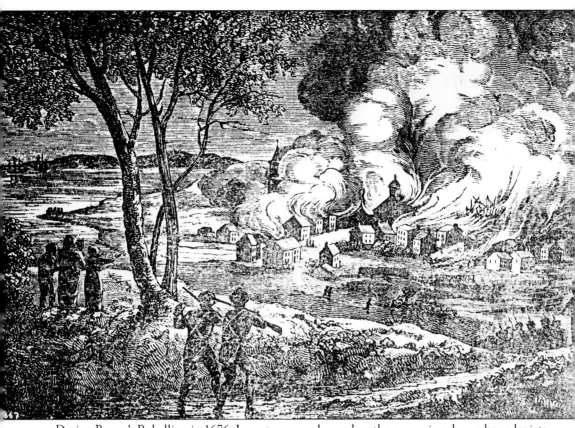

During Bacon's Rebellion in 1676, Jamestown was burned, as the engraving shown here depicts. Nathaniel Bacon (1647–1676) was a member of the Royal Governor's Council from Henrico County. With relations between colonists and Native Americans deteriorating, Bacon was recruited to take action against the Native Americans by Virginia settlers, who were upset by what they perceived to be Governor Sir William Berkeley's lack of strong policy against the "savages." Bacon requested that the governor permit him to lead an expedition against the Native Americans, but when Berkeley refused to assign Bacon such an expedition, Bacon took it upon himself to launch attacks against them in 1676. As a consequence of his actions, Berkeley declared Bacon a rebel. Bacon went on trial and was acquitted. Believing himself more popular than before, Bacon led his followers a second time in rebellion against excessive taxes, this time attacking at the heart of the colonial capital, Jamestown. When Berkeley proclaimed Bacon a rebel for the second time, Bacon captured and burned Jamestown in retribution, but Bacon died of dysentery on October 26, 1676, before he could execute any of the reforms he fought so fiercely to win. Between fires and rebellion, pestilence and devastating weather cycles, and American Indian aggressions, Jamestown was doomed from the start. A fire in 1698 proved the last straw, and by 1699, the Virginia capital had moved to Williamsburg.

Two

A Lesson in Virginia History

"The events linked with the birth of this great nation are tragic, romantic and sublime. Every true American citizen will share the pride of Virginians by participating in commemorating this event. Three hundred years have passed but near the spot of those memorable scenes is being built a magic city of splendor."

—Marion Cabiness Wilson, Class of 1907
Elizabeth City County High School

The Jamestown Exposition drew enormous national and international attention to America's and Virginia's rich history. Exhibits elicited public appreciation and admiration for the nation's past, and souvenir hunters soon found themselves overwhelmed by historical literature and photograph books that depicted that history in take-home size. Harry C. Mann and his fellow Jamestown Official Photograph Corporation photographers were sent around Virginia to document the state's inventory of precious historic landmarks. Christ Church in Alexandria, Virginia, was one of them. Harry C. Mann took this image of the church in 1907. Located at the corner of North Columbus and Cameron Streets, Christ Church was built between 1767 and 1773 from plans rendered by James Wren, one of colonial Virginia's only identifiable architects of record. George Washington attended services at Christ Church frequently. Robert E. Lee worshiped in the church in 1861 before travelling to Richmond to accept command of the Army of Northern Virginia, thereby making his allegiance to the Confederacy in the war, which would divide the Union and redefine warfare.

A Lesson Learned Well

Though there are innumerable lessons to be learned pertaining to Jamestown, the Jamestown Exposition, and the world events that precipitated the around-the-world cruise of the Great White Fleet, reading the impact of the events of 1907 as penned from a young person's perspective was a privilege only those who attended the Jamestown Exposition could appreciate—until now. In a series of representative volumes of children's work from the schools of Hampton and Elizabeth City County, patrons of the exposition had an opportunity to view the reading, writing, language studies, science, art, and arithmetic being learned by students as young as those in the first grade to young people in high school. These volumes, made available by the City of Hampton, included details and eyewitness accounts of the exposition, which proved priceless to the compilation of the event's history as the pervasive influence of American imperialism and pride in a 300-year past, emerged in the writings and art of students like Marion Cabiness Wilson, Class of 1907 at Elizabeth City County High School, who penned a final essay titled, "Jamestown." Her view of American history is colored with overtones of the United States' supremacy on the world stage. She wrote as follows:

> *The United States is today so absolutely dominant over the western hemisphere in wealth, in genius, and in military power that one can hardly realize that it lay so long neglected and unexplored. For nearly a century after the first voyage made by Christopher Columbus this whole country was a vast wilderness into which no white man had yet dared to penetrate.*

Wilson believed that we owed the founding of the United States to "a man who seldom gets the credit for it. This was the courtier, scholar, statesman, and soldier Sir Walter Raleigh. This brilliant hero was as we know a favorite of Queen Elizabeth and fascinated all by his charming manner and by the bravery which he displayed on the field of battle." For a 16, possibly 17-year-old girl, Marion Wilson proved eloquent beyond expectation as she remarked in the following:

> *The events linked with the birth of this great nation are tragic, romantic and sublime. Every true American citizen will share the pride of Virginians by participating in commemorating this event. Three hundred years have passed but near the spot of those memorable scenes is being built a magic city of splendor. That a great and powerful nation should have sprung from the little settlement made in 1607 on Jamestown Island in the state named in honor of the Virgin Queen of England, would have seemed the fancy of a deranged mind did not this great country, with a government for the people, of the people, and by the people; where all men are free and equal; and, where everyone has a right to worship according to the dictates of his conscience, stand as a sufficient proof of this fancy.*
>
> *The Jamestown Ter-Centennial is different from former expositions in several ways. In times past the advance along industrial, commercial, mechanical, scientific, educational, and artistic lines has been demonstrated by the great world fairs [sic], but its novelty is a little worn so the people of Virginia have decided to make this exposition attractive along other lines. They wish the celebration of an event so far-reaching in its results to possess those features which would distinguish it from all other expositions, and it was thought more appropriate to emphasize the historical, educational, and social sides of the occasion than the commercial and industrial, which have been demonstrated again and again for more magnificently than Virginia could hope to do.*
>
> *Again it was decided that the celebration should be an international naval, marine and military character so in carrying out this desire the President of the United States, in the name of the American people and the government which he represents, has invited all the nations of the world to send their naval vessels to celebrate the event which has had such a striking effect on the history of mankind.*

Near the end of her essay, Marion concluded: "What finer spectacle could be presented than the fleets of all nations assembled in review! What more eloquent applause than the voices of their cannon! These voices will speak in honor of Jamestown, for are they not thundering a salute to the Anglo-Saxon's progress? And offering a tribute to human freedom."

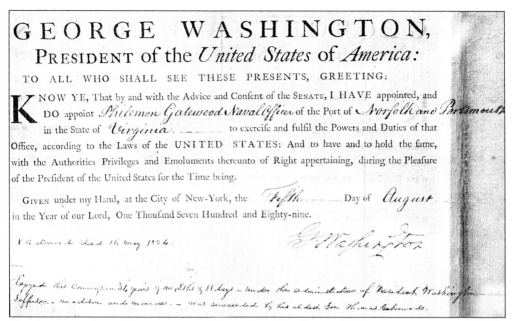

The document shown here was a commission signed by George Washington on August 5, 1789, appointing Philemon Gatewood naval officer of the ports of Norfolk and Portsmouth. Gatewood held his commission 34 years, 9 months, and 11 days, serving under the administrations of five American presidents—George Washington, John Adams, Thomas Jefferson, James Madison, and James Monroe. He died on May 16, 1824. The document was placed on display at the exposition.

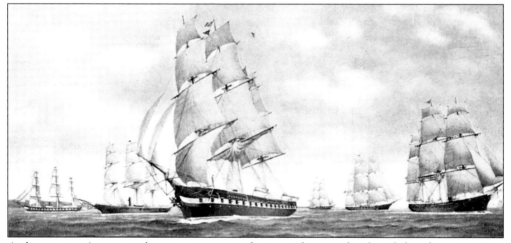

A lesson in American history, a series of postcards was developed by the exposition organizers—this one No. 71 in the series, devoted to subjects of historical importance, including the American Navy in 1812. This very rare and interesting postcard reproduction shows the American fleet of warships, including those of state navies, off the coast of Maine in 1812. It consists of the *Plymouth*, *Wachusetts*, *Juanita*, *Wabash* (flagship), *Shenandoah*, and *Brooklyn*. These sloops of war, with their canvas spread and colors streaming from the masthead, were vastly more picturesque than the fighting ships of the American steel navy, so grim and fierce when stripped for battle. Compared to the ironclad ships of the Great White Fleet, these 1812-era ships were hardly more than toy gunboats.

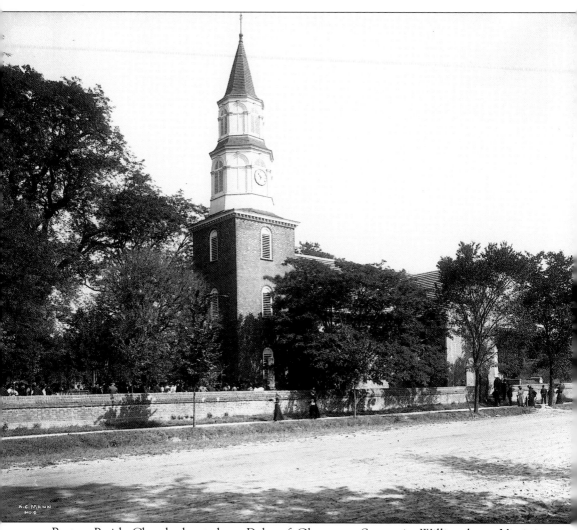

Bruton Parish Church, located on Duke of Gloucester Street, in Williamsburg, Virginia, was photographed by Harry C. Mann, c. 1908. Bruton Parish, formerly Middle Plantation and subsequently Middletown Parish, was created in 1632. Early records of the church were destroyed, but there is evidence of a frame church in Williamsburg in 1665. A second edifice, of brick, was erected in 1683. The church shown here was constructed between 1712 and 1715 on land given by Colonel John Page to replace a building adjudged insufficient to meet colonists' religious needs. Bruton Parish Church was the primary house of worship in Virginia's second colonial capital. The design of the church's oldest section was designed by Governor Alexander Spotswood, who laid out a classic cruciform-plan church, the first found in Virginia's colonial-era churches. The church was constructed by James Morris. There were two significant additions, however, one being the extension of the chancel in 1752, and the other addition of the two-tiered steeple in 1769. The clock and rounded-arch windows in the steeple were removed during subsequent restoration in 1931.

The Van Lew House in Richmond, Virginia, was postcard No. 66 produced by the Jamestown Amusement & Vending Company, Inc., as an exposition souvenir. The Van Lew House was famous as the house where Federal prisoners, escaping from Libby prison by way of a tunnel dug with their hands, were concealed and cared for until they could find means of passing through the Confederate lines. The house belonged to Elizabeth "Crazy Bet" Van Lew, a Union spy, although some say a relatively harmless little lady, during the Civil War. She lived in this elaborate mansion, razed many years ago, on Church Hill across from St. John's Church.

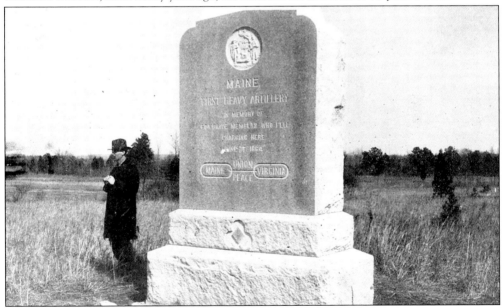

The Peace Monument, located on Hare Farm, Petersburg, Virginia, was erected in memory of both Federal and Confederate soldiers. It was in this field that 604 members of the Maine First Heavy Artillery fell in a brave charge upon Confederate positions on June 18, 1864. The total loss at Petersburg between June 15 and 19, 1864, was 11,386; June 20 to 30, 769; July 1 to 31, 1,081; and August 1 to 31, 1,077. This image, marketed in exposition souvenir books, stood as a poignant reminder of the carnage of the Civil War.

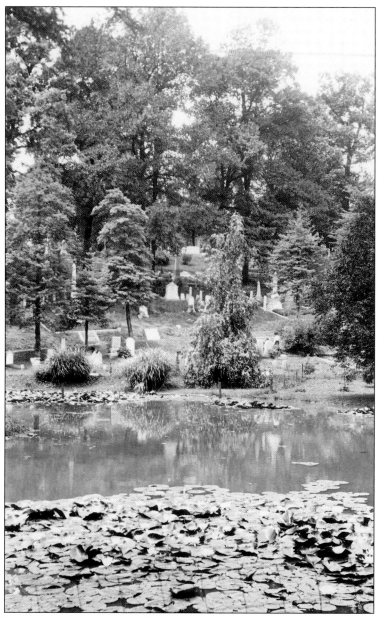
Hollywood Cemetery is spread across hills, a ravine running along the James River, and is crisscrossed by winding roadways and paths. Many famous Americans are interred at Hollywood, including Presidents of the United States James Monroe and John Tyler, as well as the only president of the Confederacy, Jefferson Davis; John Randolph, of Roanoke; J.E.B. Stuart; Matthew Fontaine Maury, the United States Navy's "Pathfinder of the Seas"; and Fitzhugh Lee, first director general of the Jamestown Exposition Company. The photograph postcard shown here, c. 1915, illustrates the cemetery's Notman design at its best. A few lines written by an unknown visitor to Hollywood describe the cemetery as follows: "The aged trees, the undulating lawns, the majestic river, the green islands, the hazy southern shore combine to make Hollywood restful and beautiful beyond description. The famous dead and nameless dead sleep well side by side. They are fortunate in the place of their sepulture."

The Confederate Monument at Hollywood Cemetery in Richmond, Virginia, was photographed by Harry C. Mann, in 1907. The dry-laid stone pyramid, shown here covered in foliage, is found at Hollywood's northwest corner and marks the graves of 18,000 Confederate soldiers. The cemetery itself was laid out in 1848 from plans rendered by a Scottish architect and landscaper who made his home in Philadelphia—John Notman. Notman pioneered lavishly appointed cemeteries and parks, and Hollywood was perhaps one of his best expressions of that style.

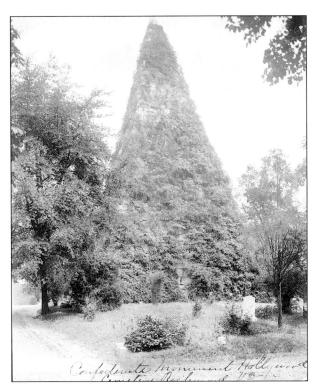

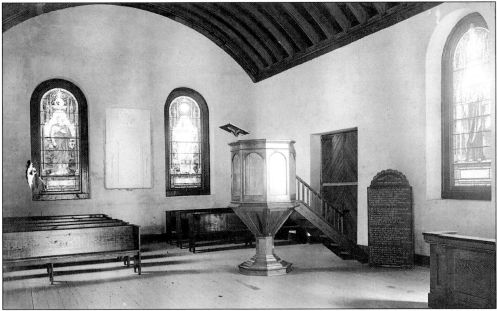

The interior of Blandford Church, Petersburg, Virginia, pictured here as it appeared in 1906, was restored as part of a major restoration project undertaken by the Ladies' Memorial Association in 1901. At the time the picture was taken, the church was being used as a Confederate memorial chapel. The chapel has memorial windows, designed by Louis Comfort Tiffany, clearly shown here, representing each of the Confederate states in addition to one special window Tiffany donated to the ladies' association. (Harry C. Mann, photographer.)

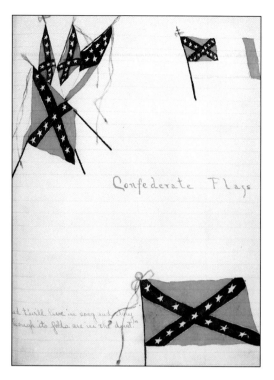

Lelia Weymouth, Elizabeth City County High School Class of 1909, wrote an insightful story called "The Confederate Flags," as her contribution to the Jamestown Exposition book provided by Hampton's and the county's schools. Lelia drew the flags pictured here.

The Confederate Flags

The stars and bars was the flag first adopted in 1861 by the Confederacy of seven states. The two outside bars were red and the central bar was white. The field of the union, occupied by seven pointed stars, was blue; the colors being the same as those of the old flag of the United States.

At Manassas, July 21, 1861, while Early's brigade was marching from the Confederate right to aid the Confederate left; his flag was folded so closely about the flag staff that Beauregard could not, at first, decide whether it was a Federal or a Confederate flag. Later, however, a slight breeze blew the folds of the flag away from the staff, and Beauregard recognized the stars and bars of the Confederate brigade. After this battle, Johnston and Beauregard agreed upon a flag to be used by the Confederate regiments upon the field of battle.

The Battle Flag or the Southern Cross was not the official flag of the Confederate states but the banner carried by the soldiers into battle. It consisted of a red field crossed by two bars of blue within narrow borders of white and containing thirteen white stars, each star having five points.

On the first of May, 1863, the Confederate Congress declared that the flag of the Confederate states should be as follows: 'The field to be white, the length double the width of the flag, with the union to be a square of two-thirds the width of the flag, having the ground red; with bars bordered with white and emblazoned with five-pointed stars, corresponding in number to that of the Confederate States.' When this flag fell in folds around the flag staff, only the white color was seen. As it looked like a flag of truce another change was necessary.

On March 4, 1865, the Confederate Congress adopted a new flag as follows: 'The width shall be two-thirds of its length with the union to be in width three-fifths of the width of the flag, and so proportioned as to leave the length of the field on the side of the union twice the width of the field below; it shall have the ground red and a broad blue bar bordered with white and emblazoned with five-pointed stars corresponding in number to that of the Confederate States, thirteen in number. The field of the flag shall be white, except the outer half from the union which shall be a red bar extending the width of the flag.' Thus the flag of the Confederate States was established.

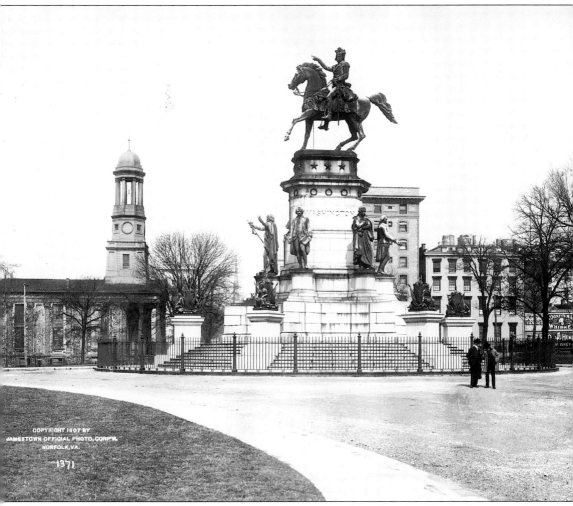

The scene in this Harry C. Mann photograph is no more. Jean Antoine Houdon's statue of George Washington was commissioned by Thomas Jefferson on behalf of Virginia, and stood in Capitol Square, Richmond, Virginia, at the time the picture was taken in 1907. The statue was subsequently moved inside the rotunda of the state capitol. The church on the left in the picture is St. Paul's Episcopal Church, located at the corner of Grace and Ninth Streets. Completed in 1845, this Greek Revival-style church is the design of Philadelphia architect Thomas S. Stewart. St. Paul's is fronted by an exceptionally beautiful portico in the Corinthian order of the Choragic Monument of Lysicrates. Robert E. Lee and Jefferson Davis frequently worshiped at St. Paul's, as have many of Virginia's governors and members of the Virginia General Assembly in the late nineteenth and twentieth centuries. President Davis was at St. Paul's when word came that Lee could no longer hold his lines at Petersburg, leading to the swift evacuation of Davis and his Confederate cabinet officers from Richmond. The church is considered one of the most active Episcopal parishes in Virginia.

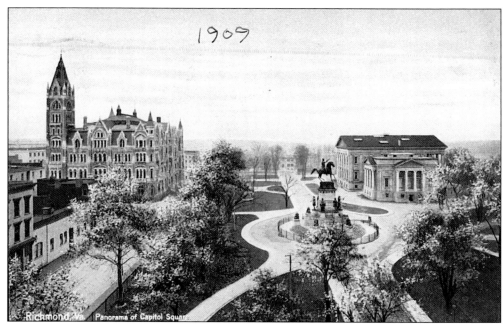

To provide some perspective, this is a panorama of Capitol Square in Richmond, Virginia, as it appeared in 1909 on a postcard sold by the Hugh C. Leighton Company, of Portland, Maine. The card itself was printed in Germany. Jean Antoine Houdon's statue of George Washington was the focal point of the square.

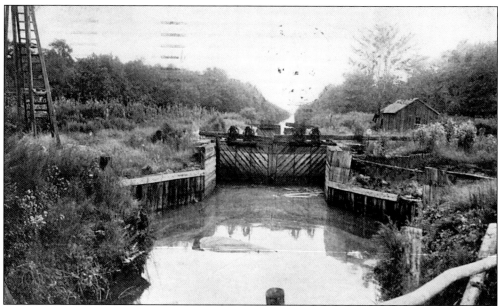

This postcard image of the Dismal Swamp Canal was printed by the American Colortype Company, of New York, for the Jamestown Amusement & Vending Company, official purveyors of an extensive series of cards depicting exposition places and people and American and national historical sites and events. The Dismal Swamp was the subject of postcard Nos. 152, 153, and 154. This is No. 152, showing the old lock mechanism and keeper's cabin.

The town of Norfolk was established by the Town Act of 1680, but in September 1736, the Norfolk Borough was established by Royal Charter because the town had proven itself to George II as amenable to trade and navigation. Samuel Boush was appointed mayor but died before qualifying for office, and in November, George Newton was chosen as mayor of the borough. Two years later, in 1738, the old Ye Chappell of Ease had become inadequate to serve the religious needs of the borough's growing population. In 1739, the Borough Church was completed as indicated by the date on the southern gable. The new church stood in the yard near the old building. The Borough Church was built in the form of a Roman cross of red and bluish semiglazed brick. Colonel Samuel Boush gave the bricks for this church and it may be that he had his father's initials S B placed on the southern gable in memorial, or that the vestry placed the good colonel's initials there in recognition of his generous contribution to the church's construction. Harry C. Mann took this picture for the Jamestown Official Photograph Corporation in 1907.

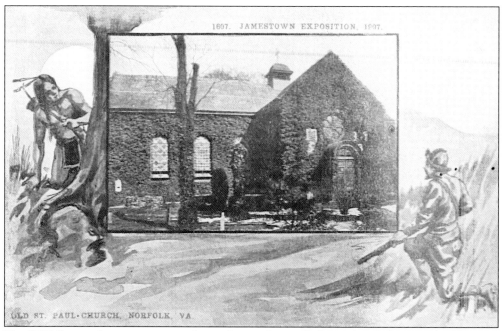

The PCK Series of souvenir postcards was designed to include a colored photograph of historic sites framed by an artist's rendering of a scene from Jamestown Island. St. Paul's Episcopal Church, Norfolk, Virginia, was featured in the PCK postcard shown here. The postcard was produced in 1906, in anticipation of the exposition.

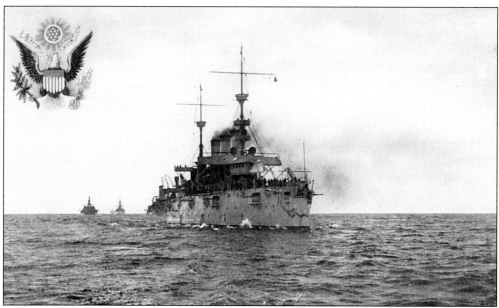

This postcard, No. 99 in the series of important events in American history, depicts the Santiago Fleet returning from the war with Spain. The fleet was entering New York Harbor when this picture was taken. Rear Admiral William T. Sampson's flagship, USS *New York*, is the battleship in the foreground. The postcard was published by the Jamestown Amusement & Vending Company, Inc., of Norfolk, Virginia. (Courtesy of the City of Hampton.)

Three

CLEARANCE AND CONSTRUCTION

"To shallow rivers, to whose falls
Melodious pirds [sic] sings madrigals;
There will we make our peds [sic] of roses,
And a thousand fragrant posies."

—From *Merry Wives of Windsor*, Act III, Scene I, c. 1600
William Shakespeare, English playwright (1564–1616)

The African-American laborers in this photograph were but a handful of the African Americans employed to perform the back-breaking work of building the palatial palaces, magnificent statehouses, and War Path attractions, which entertained thousands of exposition visitors. Harry C. Mann photographed these workers as they toiled away on the Canoe Trail, c. 1907.

The board of design of the Jamestown Exposition consisted of the six men in this photograph. They are, from left to right, as follows: (front row) J.H. Parker; Douglas H. Thomas Jr.; and J. Knox Taylor, supervising architect of the United States Treasury; (back row) John Kevan Peebles, of Norfolk; Warren H. Manning, chief landscape architect of the exposition; and Robert S. Peabody. Peebles had formed a partnership with Parker & Thomas, of Boston and Baltimore, and their partnership soon affiliated with W.H. Manning & Brother, of Boston. Later, Robert Peabody, of Boston, a leading architect of his day, joined the exposition's design team, bringing with him the experience of having served on the Chicago exposition's board of architects.

A group of pine trees on the exposition grounds at Sewell's Point was photographed by an unknown photographer about 1906. In 1586, Ralph Lane and his expedition visited this spot, then occupied by the Chesapeake Indians. In 1905 a Native American burial ground was discovered here. Also, in this location, the Confederates constructed two batteries in 1861, and on March 9, 1862, during the USS *Monitor* and CSS *Virginia* (*Merrimack*) fight, the batteries fired upon the USS *Roanoke*, *Minnesota*, and *St. Lawrence*.

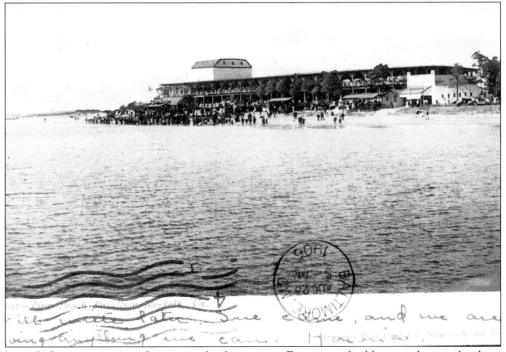

Long before construction began on the Jamestown Exposition buildings and grounds, there was the Pine Beach Hotel and Pavilion, situated on Pine Beach. The postcard shown here, printed by the Souvenir Post Card Company, New York and Berlin, shows a busy resort attraction, c. 1906.

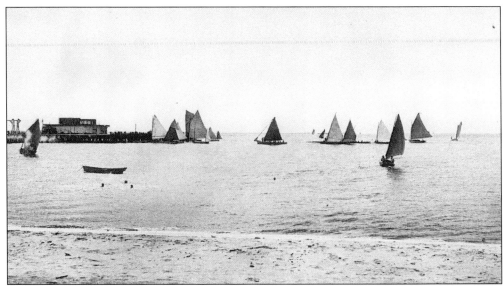

The postcard shown here pictures various sailing craft in Hampton Roads, in close proximity to the Pine Beach pier. Published by the Souvenir Post Card Company, of New York and Berlin c. 1905, it is a rare and seldom seen snapshot of a part of Hampton Roads changed forever by the Jamestown Exposition.

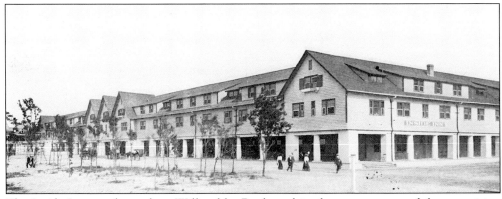

The Inside Inn was located on Willoughby Boulevard in the western part of the exposition grounds, facing Hampton Roads. With its unobstructed view extending many miles, the Inside Inn was an ideal spot for rest and enjoyment of the area's incomparable sea breezes. The hotel could accommodate 1,600 guests, and during the Jamestown Exposition, this capacity was tested many times. The inn was called the "Inside" inn because it was located inside the exposition grounds, while the Pine Beach Hotel was not.

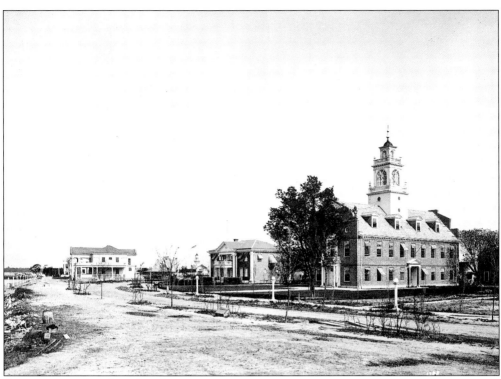

Construction of roads, sidewalks, and fences, in addition to the lovely landscaping that the Jamestown Exposition would become renowned for, was incomplete when this photograph was taken by a company photographer, Harry C. Mann, in 1907. The Massachusetts Building is in the foreground, and next to Massachusetts, on the left, is the Illinois Building. Completion of the grounds did not occur until September 1907, a little less than two months before the exposition closed.

Warren H. Manning, landscape architect for the Jamestown Exposition, was photographed in 1904 for promotional literature touting the wonders of the coming world event in Hampton Roads, much of which could be attributed to Manning's brilliant landscape and garden compositions. His designs were in keeping with the Colonial Revival-style architecture that would define the exposition.

Much of the natural terrain was left intact for the exposition, with a couple of earth-moving exceptions. The first image (top left) shows the dense growth of timber on the grounds, while the second image (top right) depicts "Lover's Lane," or "Flirtation Walk." The Canoe Trail (both bottom images) was 12 feet wide and 2 miles long. The Jamestown Exposition's landscape designers opted to keep picturesque scenery as part of the grounds to offer patrons a slice of God's green earth unsurpassed by any other exposition.

The Canoe Trail remained one of the loveliest venues of the exposition.

Construction of the nature walk and "Lover's Lane" required a couple of major alterations to the natural landscape at Sewell's Point, as this postcard image attests. Earth had to be piled high and natural vegetation stripped and moved around to accommodate the landscapes planned by Warren H. Manning.

The Winding Trail, an integral part of the great outdoors adventure of the Jamestown Exposition grounds, appeared on a souvenir postcard published by the Jamestown Amusement & Vending Company, Inc., Norfolk, Virginia, in 1907.

One of the most instructive and interesting aspects to the Jamestown Exposition was the multitude of geographical lessons proffered by outdoor exhibits such as this one of the Panama Canal route. The Panama Canal Zone, as the region was then called, is shown here in relief, enabling visitors to obtain a clear picture of the topography of Panama and of the work in which the United States was engaged as they built the canal locks to allow for the passage of ships. The canal exhibit was constructed under the supervision of the Isthmian Canal Commission. The reproduction was 122 feet long and 60 feet wide, and was constructed of concrete, its surface roughened and painted green to represent a forest-clad area viewed from a distance. A cement wall about 5 feet high on the inside and 2.5 feet on the outside gave the map an effect of a framed picture or panorama, and visitors could see the whole line of the waterway from its beginning in the Caribbean Sea at the entrance of Limon Bay, to its end, 50 miles distant, near the Island of Naos, off Panama's Pacific coast. Completion of this exhibit took several weeks, construction inhibited by inclement weather in Norfolk.

Four

Party Plans and Souvenirs

"If Manhood's waves have borne our bark
Far distant from the shore,
Whose pleasant scenes were dear to us
When life its blossoms bore—
Tis sweet, when we come back again,
To find each spot we knew,
Deck'd in the self-same joyous garb
Our youth around it threw."

—From "Souvenirs du Jeune Age," *Southern Literary Messenger*, Volume 6, Issue 3
W.T.S., March 1840

This couple was on their honeymoon when they stopped at the Crawford-Wagoner Studio in Ocean View, Virginia, which in 1923 became part of the city of Norfolk, to have their photograph made for a friend, Dot Bratten, of Princess Anne, now part of the city of Virginia Beach. The woman in the picture was named Hazel. The reverse of the postcard has a printed piece on the back indicating the card was made specifically during the Jamestown Exposition as a souvenir.

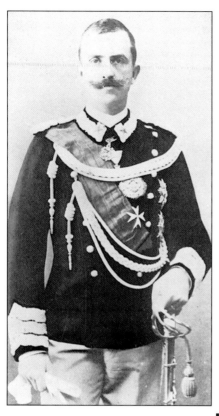

Henry (Harry) St. George Tucker, president of the Jamestown Exposition Company, went on a tour of Europe in 1905 to solicit the participation of Austria, Germany, Italy, France, and Great Britain and her commonwealths. While in Italy a couple of days before Christmas, Tucker visited Victor Emanuel III (pictured here, left), king of Italy, and after a brief stop in Paris, proceeded to England, where he arranged an audience with King Edward VII. The British monarch was eager for England to be represented at the exposition and pledged his full support. Tucker returned to New York City on January 21, 1906.

David Lowenberg, of Norfolk, was director general of the exposition from 1902 to 1905. When incorporators of the exposition convened on April 16, 1902, their primary task was to name directors. Sixteen of the eventual 49 directors named came from Norfolk. Lowenberg quickly ascended to the executive committee of the Jamestown Exposition Company. He served in the formative years of the tercentennial enterprise when the executive circle consisted of Nathaniel Beaman, T.S. Southgate, Barton Myers, C. Brooks Johnston, S. Gordon Cumming, Alvah H. Martin, Thomas J. Wool, C.S. Sherwood, George F. Adams, and J.L. Patton.

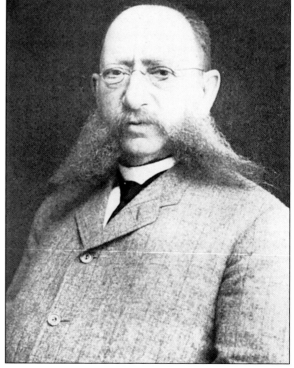

The Jamestown Exposition Fire Department was organized in the fall of 1906, with Thomas Reynolds as chief. Reynolds remained chief of the exposition fire department until August 1, 1907, when he was succeeded by John T. Goddin. The exposition fire department used two extra large Nott steam engines, two combination hose and chemical engines, a Hayes aerial truck, and two hose wagons. There were 40 firemen and 14 horses serving the department. It was necessary to provide a capable firefighting force on the exposition grounds since an immediate response could not have been obtained from city of Norfolk fire stations, located too far away. The Jamestown Exposition Fire Department was called out on many occasions in response to fires and injured participants and patrons.

The Atlantic Hotel, located at the corner of Main and Granby Streets in Norfolk, was the headquarters of the Jamestown Exposition Company prior to completion of the company's building on the exposition grounds in 1907. This postcard image, printed about 1906 in Germany for A.C. Bosselman & Company, of New York, was mailed by a Norfolk gentleman to a young lady in Copenhagen, New York, on February 24, 1907.

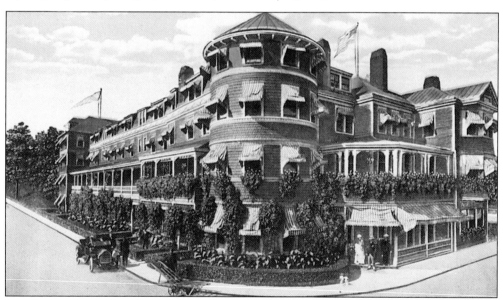

In order to accommodate the multitude of visitors to the exposition, planners understood that the Pine Beach and Inside Inns would not provide enough rooms for event patrons. In anticipation of the exposition, hotels were built in Norfolk, Portsmouth, Hampton, and Newport News, and those that were established hostelries either renovated or spruced up their concerns. The Sherwood Inn at Old Point Comfort, Hampton, Virginia, was one of the existing hotels that housed hundreds of guests to the exposition. This image of the Sherwood Inn was published by Louis Kaufmann & Sons, of Baltimore, Maryland, c. 1910.

The Hotel Neddo was run by R. Neddo, shown here carving a rack of ribs. The hotel was one of Norfolk's best establishments in the early twentieth century. The Neddo was renowned for its fine Southern cooking.

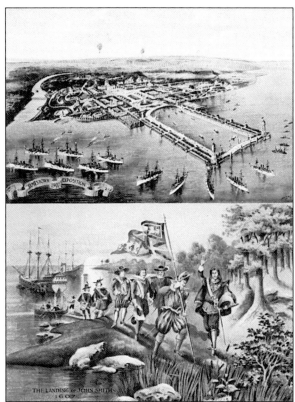

One of the more difficult souvenirs to acquire pertaining to the Jamestown Exposition, this postcard interprets the landing at Jamestown, shown at left below the bird's-eye view of the Jamestown Exposition. The postcard was made in Germany for A.C. Bosselman & Company, of New York.

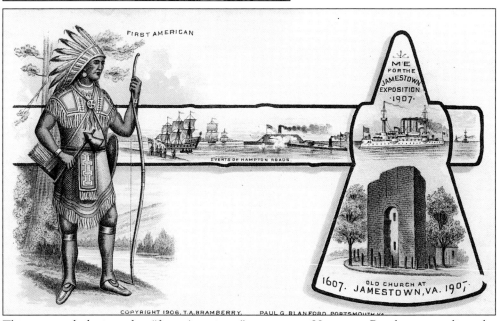

This postcard depicts the "first American," events in Hampton Roads surrounding the engagement of the CSS *Virginia* and USS *Monitor*, a depiction of a vessel from the Great White Fleet, and an image of the old church at Jamestown. The postcard was copyrighted in 1906 by T.A. Bramberry and Paul G. Blanford of Portsmouth, Virginia.

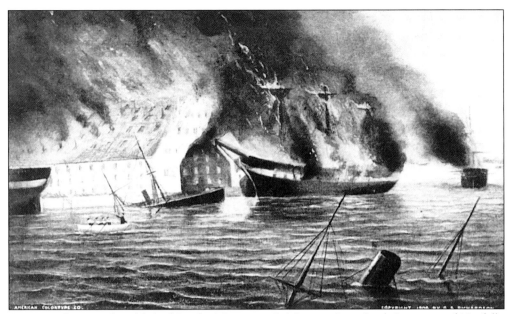

A series of postcards published by the Merrimac & Monitor Post Card Company of Norfolk, Virginia, in 1907, depicted the famous engagement March 8 and 9, 1862, between the ironclad CSS *Virginia* (*Merrimack*) and the Union fleet, and the Battle of the Ironclads, involving the *Virginia* and USS *Monitor*. The paintings on the postcards were taken from Benjamin A. Richardson's original paintings. The first postcard (shown here) shows the USS *Merrimack* destroyed during the burning of the Gosport Navy Yard, on April 19, 1861.

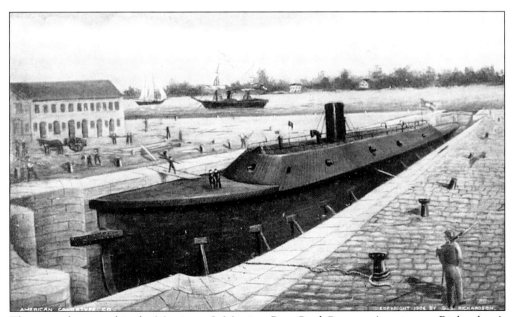

The second postcard in the Merrimac & Monitor Post Card Company's series was Richardson's painting of the *Merrimack* in drydock being converted to the ironclad CSS *Virginia*.

65

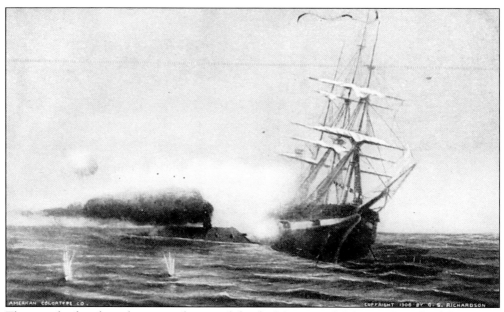

This was the fourth in the series of postcards by the Merrimac & Monitor Post Card Company. The dramatic image of the CSS *Virginia* sinking the USS *Cumberland* in Hampton Roads on March 8, 1862, made this particular postcard a popular collectible.

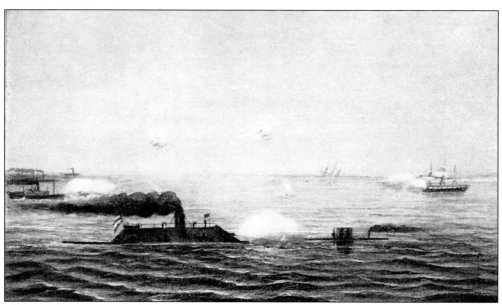

The actual engagement of the CSS *Virginia* and USS *Monitor* on March 9, 1862, in Hampton Roads was the scene chosen for the fifth postcard in the Merrimac & Monitor Post Card Company's popular series.

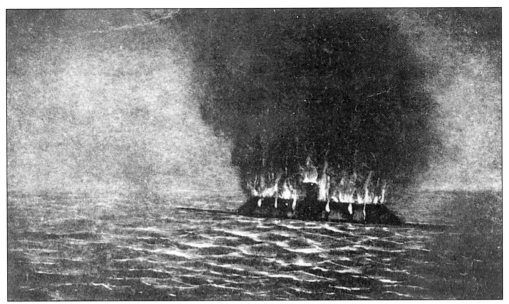

Benjamin A. Richardson painted the entire service of the CSS *Virginia*, including this scene, No. 6 in the series, of the *Virginia*'s destruction on May 11, 1862. The postcard company followed suit by placing Richardson's work in souvenir form on thousands of postcards.

The Virginian-Pilot Building was erected by the Norfolk-based newspaper for the use of its reporters covering the exposition. The newspaper approved a Queen Anne-style building, attractive and heavily used by reporters, to the east of the plaza leading from the main entrance.

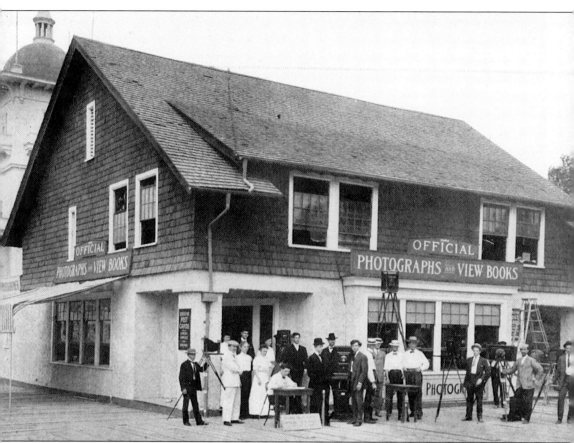

The Jamestown Photographic Corporation functioned as an auxiliary to the publicity department of the exposition. The corporation's pictures were largely used to promote the exposition around the United States, hence images, some of them quite rare, have shown up in locales across the country in subsequent years. Their building, located at the head of the War Path on the west end of Commonwealth Avenue, was the headquarters for official view books, postcards, photographs, and all kinds of souvenirs. Harry C. Mann, wearing a fedora, his hand tucked in his pocket, is standing to the immediate right of the fellow sitting at the desk. It was fortuitous that Harry Mann's brother, Colonel James Mann, was a counsel for the Jamestown Photographic Corporation. Harry was given a position with the corporation, at which time he was lured by association to staff photographers and cameras to the picture-taking profession. He was a natural, his earliest photographs serving as a permanent record of our rich history. Born in Petersburg, Virginia, on June 8, 1866, Harry Mann died at the age of 60 on December 12, 1926, in Lynchburg, Virginia.

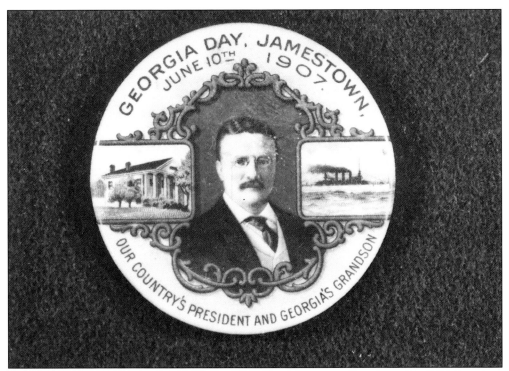

This was the commemorative button issued in honor of Georgia Day, June 10, 1907. President Theodore Roosevelt was the keynote speaker.

These passes for shows along the War Path are but a small selection of the paper tickets and passes used during the Jamestown Exposition. The passes shown here (top to bottom) are for the Monitor & Merrimac [sic], Beautiful Orient & Streets of Cairo, Ferari's [sic] Arena & Jungle, and 101 Ranch Wild West Show. Passes nearly always had a blank line for a man's name to be handwritten followed by the phrase "and a lady."

Members of the Connecticut commission to the exposition issued this medal in honor of their state's participation in the event. Connecticut Day was celebrated October 16, 1907, and included ceremonies led by Governor Rollin S. Woodruff, who paid an official visit to Virginia Governor Claude A. Swanson.

The items in this image represent but a small assortment of souvenirs issued during the exposition. From commemorative spoons, buttons, and cigarette lighters, the variety and detail of these objects were impressive.

The commemorative plate in this photograph was issued in honor of the battleship USS *Virginia* (BB-13) specifically for the Jamestown Exposition.

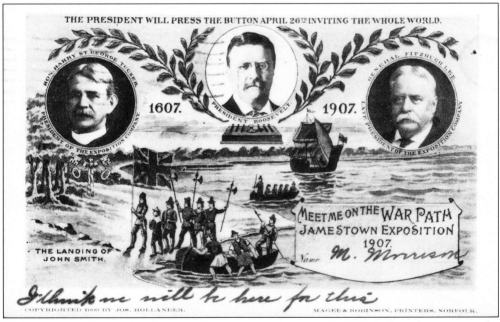

This postcard is interesting for several reasons, not the least of which is the advertisement for "Meet Me on the War Path." The postcard has an image of President Theodore Roosevelt (center) and Harry St. George Tucker, president of the Jamestown Exposition Company, on the left, and a picture of Fitzhugh Lee, late president of the exposition company, on the right. The caption above the president reads, "The President will press the button April 26th inviting the whole world."

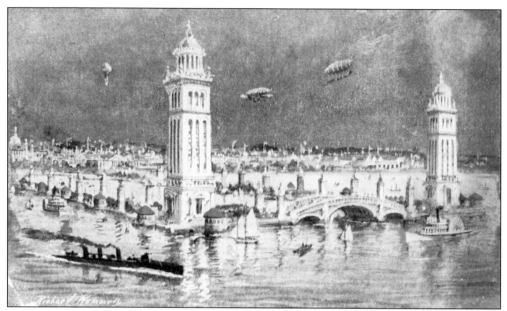

Richard Rummely painted this oil-on-canvas rendering of the Government Pier at the exposition. Rummely's art was then reproduced on postcards, like this one, and souvenir picture books. The American Colortype Company, of New York, manufactured this image for the Jamestown Amusement & Vending Company, official concessionaire of the exposition.

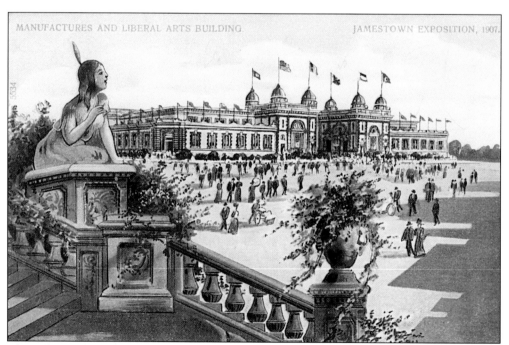

The Palace of Manufactures and Liberal Arts Building was a popular image on postcards and souvenirs at the exposition. This one was printed in Germany by A.C. Bosselman & Company from an artist's rendering.

The Prudential Insurance Company of America, home office in Newark, New Jersey, had a series of cards depicting the history of Jamestown printed for distribution to exhibition-goers. The first one, shown here, depicts the settlers repelling an attack by Native Americans. The Prudential Insurance Company received a gold medal in the Division of Social Economy for its displays: replicas of the Prudential's three office buildings from 1875, 1878, and 1883. The company had been in business for 32 years at the time of the Jamestown Exposition.

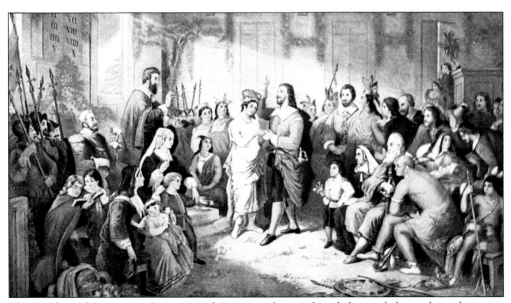

The Prudential Insurance Company of America also produced the card shown here depicting the marriage of Pocahontas.

Egg-O-See Cereal Company, of Quincy, Illinois, produced this trade card for distribution at the Jamestown Exposition, where the company had an impressive exhibit in the Food Products Building. Many of the exposition's exhibitors distributed these cards, but this one is particularly pristine—and valuable. The composition of the card includes all the elements that make the art of trade cards and postcards desirable: dogs, cats, children, and unused condition. The art on trade cards of this period is amazingly fine quality, with well-known artists and graphic designers contributing their talents to this format. Trade cards were already popular at the time of the exposition, most of them either given away by travelling salesmen, but more often presented to customers by retail and grocery store establishments to advertise all kinds of goods from dry goods and pharmaceutical cure-alls, to pianos and female toiletries. In general, they reflected the humor and freedom of advertising indicative of the Victorian era, but also some of the very best of the chromolithographic printing and pictorial designs of the period.

"Buster and Tige," mascots of the Brown Shoe Company, St. Louis, Missouri, were featured in the company's exhibit at the exposition. The L-shaped booth was heavily carpeted, and all the woodwork was wrought from cherry wood. In large plate-glass cases, the shoe company exhibited its leading styles of shoes for men and women, and the "Buster Brown" shoe for boys and girls.

"BUSTER AND TIGE"
Brown Shoe Co. Exhibit
St. Louis, Mo.

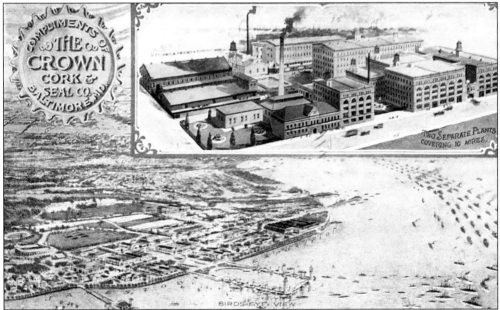

The Crown Cork & Seal Company, of Baltimore, Maryland, printed this postcard as their souvenir at the exposition. A picture of the company's plant is in the inset box. Crown Cork & Seal was the originator of designs for Crown corks, aluminum stoppers, and loop seals. Nearly every beverage manufacturer in the United States used their product at that time. (Courtesy of the City of Hampton.)

The National Cash Register Company's exhibit at the Jamestown Exposition was located in the north end of the interior court of the Palace of Manufactures and Liberal Arts. National Cash Register built a miniature theatre with opera chairs and a white curtain. The postcard was printed in 1906, in anticipation of National Cash Register's forthcoming participation in the Hampton Roads event. The card reads, "Trip from Jamestown to the National Cash Register Factory at Dayton, Ohio." There is also an incentive to visit the company's exposition exhibit since they had underwritten the showing of motion pictures and colored stereopticon slides to view on the hour for visitors. (Courtesy of the City of Hampton.)

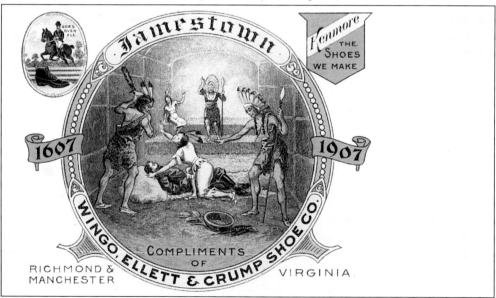

In the category of hard-to-come-by trade or postcards from the Jamestown Exposition is the one shown here, a product of Wingo, Ellett & Crump Shoe Company, of Richmond and Manchester, Virginia. The lithograph in the center of the postcard, manufactured in 1906 for the company's participation in the exposition by A. Hoen & Company, of Richmond, depicts Pocahontas saving the life of Captain John Smith.

Five

PALATIAL PALACES AND GOVERNMENT PARTICIPATION

"[History] hath triumphed over time, which besides it nothing but eternity hath triumphed over."

—From *The History of the World*, 1615
Sir Walter Raleigh, English explorer and poet (1552–1618)

Government Building A was photographed by Harry C. Mann on a busy afternoon at the exposition.

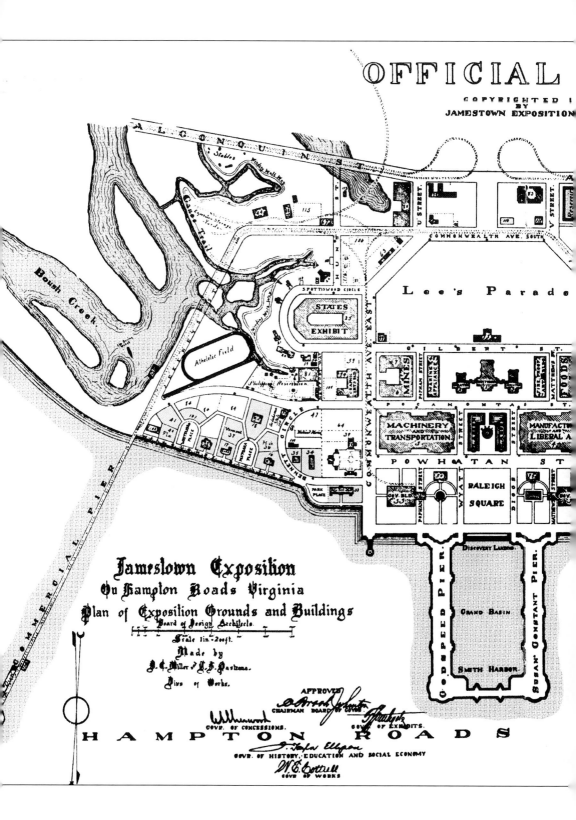

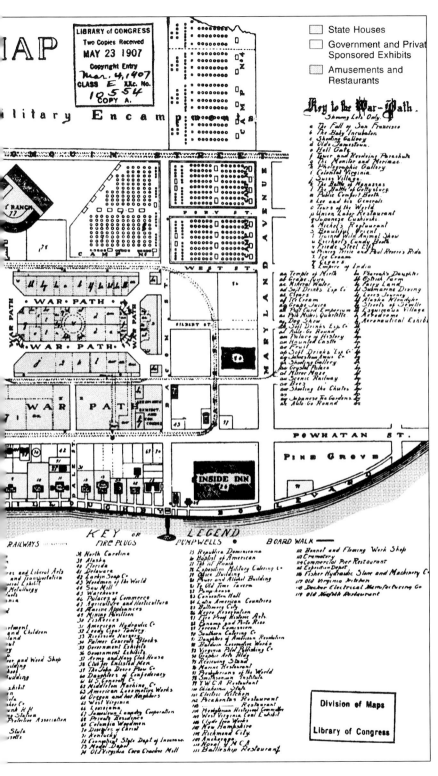

The official map of the Jamestown Exposition shows the state houses; government-sponsored and privately sponsored exhibits; and amusements and restaurants. (Courtesy of the Hampton Roads Naval Museum.)

The tower shown here was one of two standing on the Government Pier, grand in size and simplicity, lovely by day, but magnificent by night as the towers were lit by thousands of electric lights.

The Auditorium at night was gloriously lit by electric light when Harry C. Mann took this photograph.

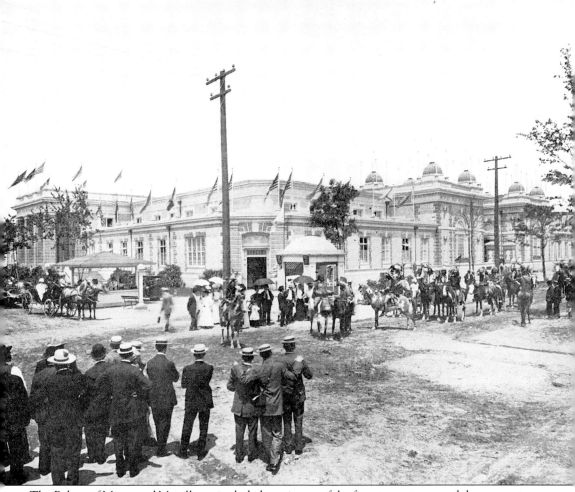

The Palace of Mines and Metallurgy included specimens of the finest gemstones and the coarsest, but none the less valuable for the output of coal and iron and other mined substances, with the machinery used in their extraction and processes of treatment. With several of Virginia's adjacent states being large coal producers, coal took a leading position among the minerals exhibited in the hall. Besides the wide array of items displayed in the general exhibition area, the commonwealth of Virginia filled one entire building exclusively with the products of its mines and forests, setting out an extraordinary display for the general public. The photograph shown here is also of interest because the Miller Brothers 101 Ranch Wild West Show performers are parading down the streets of the exposition prior to one of their performances to drum up business. Note the Native Americans on horseback.

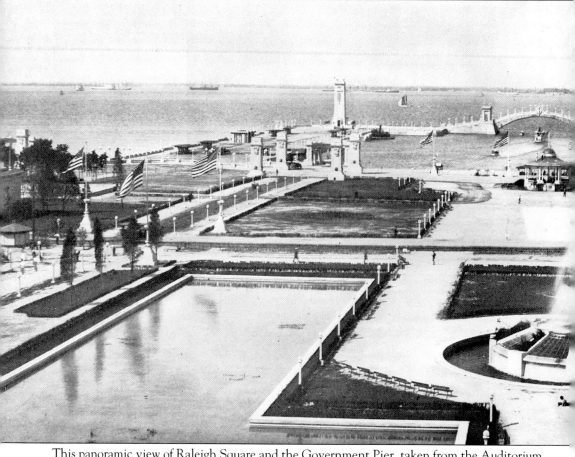

This panoramic view of Raleigh Square and the Government Pier, taken from the Auditorium, demonstrates how beautiful and magnificent the buildings in this part of the Jamestown Exposition were designed. The Government Pier stretched far out into Hampton Roads, its stately pylons standing in graceful lines a little over a thousand feet along Willoughby Boulevard. Between the pier's two arms, with their pergolas and landing places clearly shown here, was the Grand Basin with its 1,280,000 square feet of surface area. This area stood out by

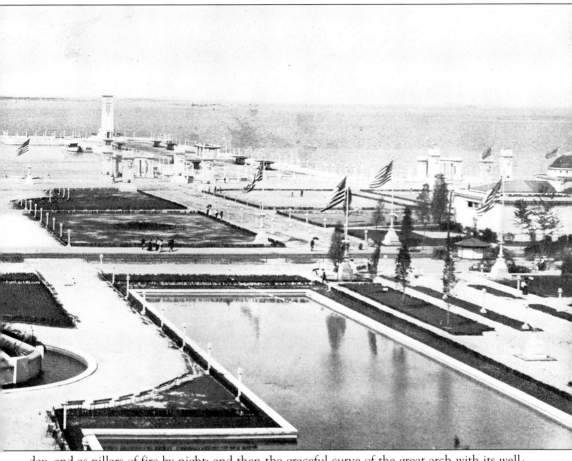

day, and as pillars of fire by night; and then the graceful curve of the great arch with its well-proportioned columns and simple but effective ornamentation united to form a symmetrical and grand promenade for visitors. The pier was 1,200 feet long, 847 feet wide, and the basin was 1,163 feet long and 547 feet wide, the bridge spanning 151 feet, and the pillars, one of which stood on either side, were 80 feet high. The entire project was designed in keeping with the Colonial-style construction, which prevailed throughout the exposition.

The Palace of Historic Art contained paintings, mostly subjects pertaining to Colonial-period history, added to which was a great collection of original documents, ceramics, and so on, forming the most remarkable collection of these items ever assembled relating to Colonial America. In the collection of works of art, much of which was considered invaluable at that time and would still be today, were extensive contributions from Massachusetts, Rhode Island, Vermont, New York, New Jersey, Pennsylvania, Ohio, West Virginia, North Carolina, South Carolina, Georgia, and Virginia. Collections of great interest to exposition visitors also included those contributed by the Episcopal Church, the Colonial Dames, the Daughters of the American Revolution, and the collection of portraits loaned by Thomas F. Ryan. The building was constructed with elaborate fire-proofing methods.

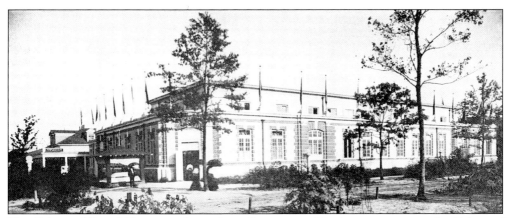

The Palace of Social Economy, located on Commonwealth Avenue opposite the Palace of Mines, included exhibits by the American Federation of Labor; several blind institutions; and the National Society for Study and Prevention of Tuberculosis.

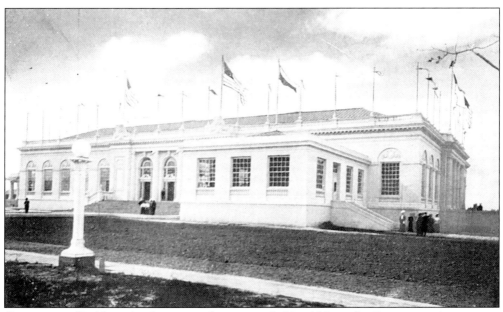

Government Building A, shown on this postcard, No. 181 in the Jamestown Amusement & Vending Company official souvenir series, housed exhibits by the Departments of Interior, Agriculture, and Treasury, as well as those of the Library of Congress and the United States Post Office.

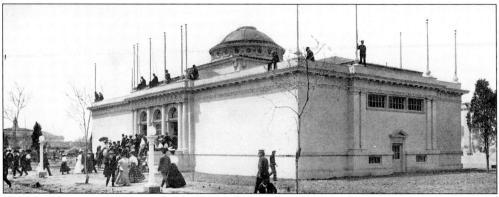

The government buildings housed some of the most interesting exhibits seen by patrons at the exposition. The Fisheries Building provided wonderfully instructive lessons on the beneficent work of the fisheries commission to propagate food fishes, and to restock lakes, rivers, and the waters of the bays and inlets along the United States' extensive shores. The fisheries exhibition received many visitors. The interior photograph (below) demonstrates the detail with which exhibit designers laid out the building's floor plan to allow patrons to view both a practical and historical panorama of life on the water.

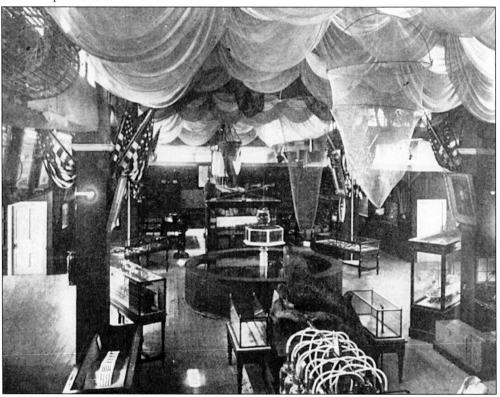

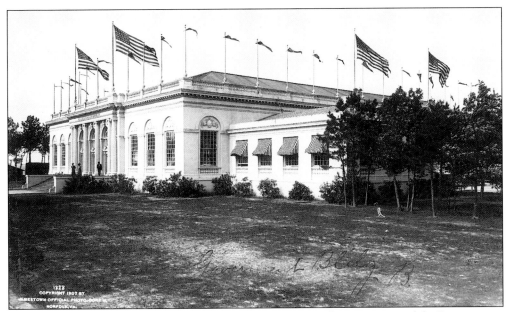

Government Building B housed exhibits by the War and Navy departments, and the Departments of State and Justice. (Harry C. Mann, photographer.)

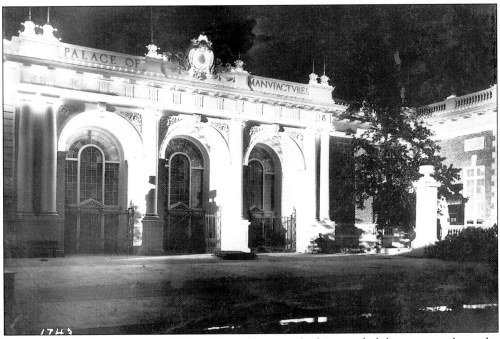

The Palace of Manufactures and Liberal Arts, photographed just as dark began to settle on the exposition grounds, made this a striking picture.

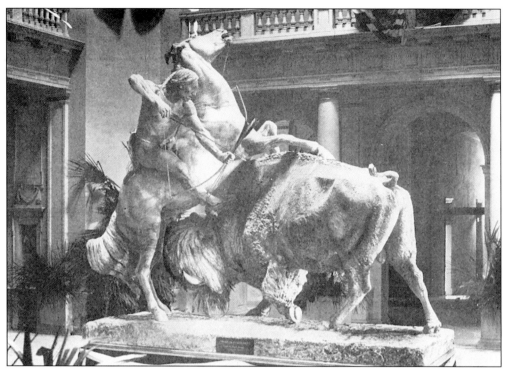

The Buffalo Hunt was a spirited sculpture on display in the auditorium of the west end of the Educational Palace. It is but one example of the fine art on exhibit at the exposition. The sculpture was rendered by Henry Kirke Bush-Brown, of Newburg, New York, son of Henry Kirke Brown, sculptor of renowned bronzes such as the one cast in 1852 of Henry Clay, begun shortly after the senator's death. The elder Brown's work is well represented in the Old Senate Chamber, United States Senate Collection, and it would be his son, the sculptor of *The Buffalo Hunt*, who completed the Clay work.

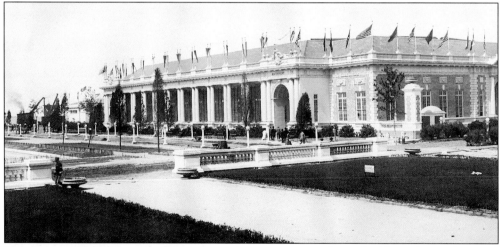

The Palace of Machinery and Transportation was a magnificent building. Located east of Raleigh Square, the Palace of Machinery and Transportation corresponded exactly in size and detail with the Palace of Manufactures and Liberal Arts, which stood on the western boundary. The building housed machines and mechanical devices.

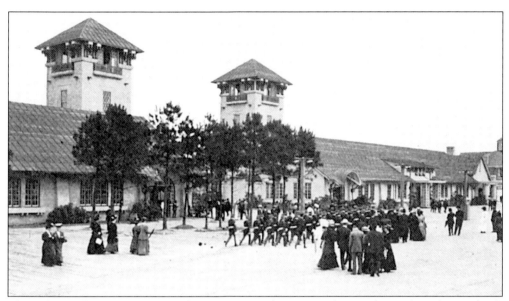

The Palaces of Commerce sat at the entrance to the War Path. Merchants from foreign lands displayed their wares within these two structures. The palace on the right was principally devoted to the display of Japanese goods and merchandise, causing many passersby to call the palace the "Japanese Palace of Commerce."

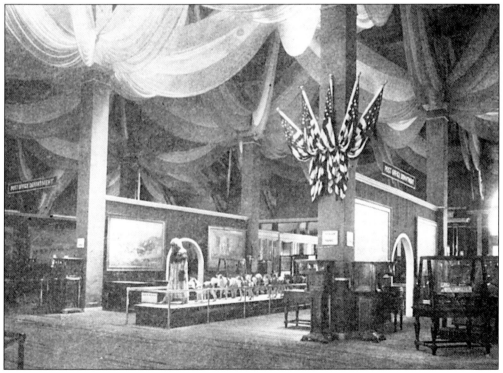

Tucked into one of the government building exhibition halls was the post office department, its displays demonstrating a variety of equipment, postage stamps, and modes of delivering the mail—depending on where one lived.

89

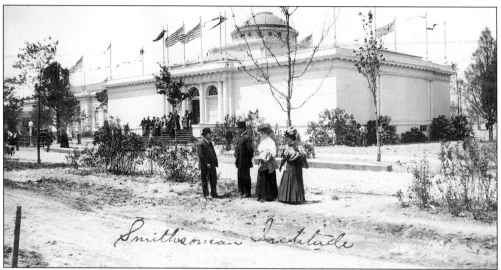

The Smithsonian Institution and National Museum Building was west of Raleigh Square and connected by a colonnade with Government Building B. The United States Congress limited the Smithsonian Institution and National Museum's display to "such materials of an historical nature as would serve to impart a knowledge of our colonial and national history."

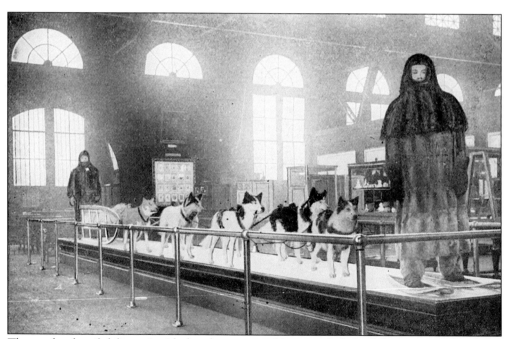

The mode of mail delivery in Alaska, demonstrated here, included a fully equipped dog sledge capable of carrying well over 400 pounds of mail. The postal service used two men and seven dogs on each sledge. Mail-delivery trips lasted anywhere from 30 to 90 days in the frozen reaches of America's northwest territories. While the people in this exhibit are merely finely crafted mannequins, the dogs were once very much alive. A taxidermist prepared, stuffed, and mounted the animals for the exhibit.

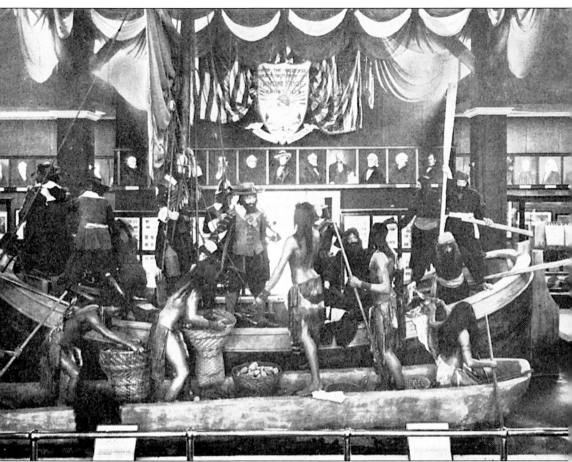

Occupying the center of the floor in the Smithsonian Institution and National Museum Building was this large tableau of 22 life-sized figures portraying Captain John Smith trading with Native Americans for corn. The exhibit was designed by W.H. Holmes, chief of the Smithsonian's American Ethnology Division and curator of the National Gallery of Art. Eleven of the group were white men, dressed with historic accuracy, replete with helmets, rapiers, and match-lock guns and pistols such as those that had been carried by the first English settlers. The boat is a reproduction of *Pinnace*, which had been used by Smith in surveying the Chesapeake Bay and Virginia's rivers. The corn in the display was grown from seed carried by the Tuscaroras to New York in 1711. The special consequence of this group lies in the fact if Smith had not succeeded in trading with the Native Americans, the Jamestown colony would surely have been annihilated.

This bust of Marquis de Lafayette was voted on by the General Assembly of Virginia on December 17, 1781, as a lasting tribute to Lafayette's loyalty and devotion to the American cause as a major general in the service of the United States in its revolution against Great Britain. Harry C. Mann photographed the sculpture for the exposition company in 1906.

Buildings at head of Grand Basin facing Raleigh Square included the Auditorium (center), flanked by the University and College Education Building (left) and the Primary and Secondary Education Building (right).

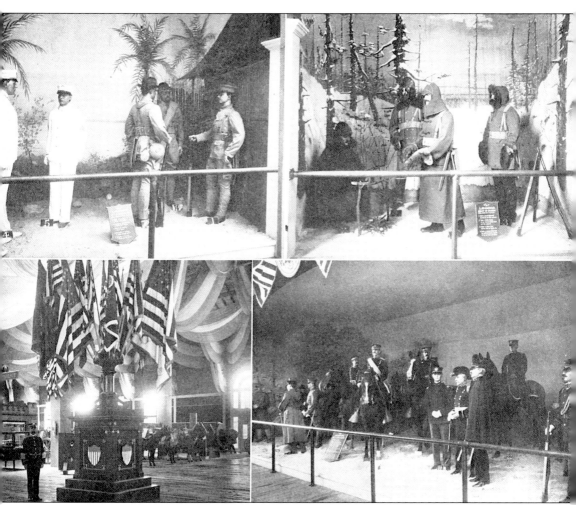

The interior of the west wing of the Government Building B contained realistic exhibits of military men and government exploration teams in period uniforms. The horses, mules, and donkeys visible in the lower scenes were real animals that had been taxidermed not only for the exposition, but for the purpose of display in museums and nature preserves around the country. The scene (top left) exhibited a group of American soldiers in the Philippine uniform adopted the United States Army. The second view (top right) demonstrated the Alaskan uniform, while the scene at bottom right demonstrates the uniforms of officers and enlisted men of the Army. These views suggest a broad territorial influence on military uniforms of the era. The scene (bottom left) is the standard of flags adorning the center of the west wing of the building.

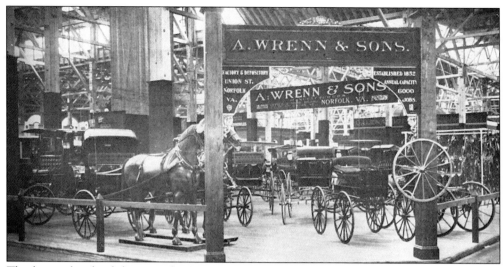

The largest local exhibitor at the Jamestown Exposition was A. Wrenn & Sons, of Norfolk, Virginia. The company occupied a prominent place in the Palace of Machinery and Transportation where their buggies, runabouts, traps, surreys, together with a fine collection of harnesses, were displayed. A. Wrenn was established in Norfolk in 1852 for the purpose of supplying local demand for its exceptionally well-made products. At the time of the exposition, A. Wrenn was turning out over 6,000 vehicles a year, not counting all the accessories.

The piers at the basin, excluding the bridge, were considered the single-most important contribution made by the United States government to the Jamestown Exposition. The board of design of the exposition oversaw the pier project, but it was superintended by Major Spencer Cosby, of the United States Army Corps of Engineers (pictured here). The piers were built by Scofield Company, of Philadelphia, who were the sole bidders on the project. Work on the piers moved slowly due to inclement weather. Typical of most of the construction that took place on the exposition grounds, the piers were incomplete when the exposition opened. According to Cosby's report, the project was nearly complete by June 30. The United States government operated a wireless telegraph from the top of the main arch of the bridge erected between the piers.

Six

Opening Day Pomp and Circumstance

"O God of Nations, by Thy guiding hand
 Were our forefathers led to this blest shore,
When they were seeking for some friendly land
 Where they Thy praise, from fervent hearts might pour
In deep libations. They had naught to fear
 from persecution's rack, or bitter strife.
Or gross exactions, often hard to bear,
 Which compassed all their daily round of life.
Their first famed act on Cape Henry's shore
 Was planting of the Cross, with grateful mien,
Then with loud voice, above the ocean's roar
 Proclaimed their faith in what was yet unseen."

—From *The Official Hymn of the Jamestown Exposition*, 1907
Wilberfoss G. Owst, composer, and William M. Pegram, lyrics

United States Marines from the battleship USS *Ohio* (BB-12) are shown here as they marched in the opening day parade of the Jamestown Exposition. The marines had been embarked on *Ohio* as part of a Far East tour. The battleship, flagship of the Asiatic Fleet, departed San Francisco, California, on April 1, 1905, bound for Manila, in the Philippine Islands, at which time she embarked the party of then Secretary of War William Howard Taft and President Theodore Roosevelt's daughter, Alice, who led the American group on much of its inspection tour. The cruise took sailors and marines aboard the *Ohio* through Philippine, Japanese, and Chinese waters until returning to the United States to participate in the Jamestown Exposition in 1907. (William H. Lee, photographer.)

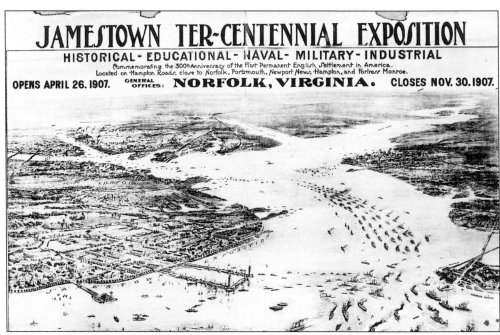

This was one of the most pleasing artistic renderings of a bird's-eye view of the Jamestown Exposition.

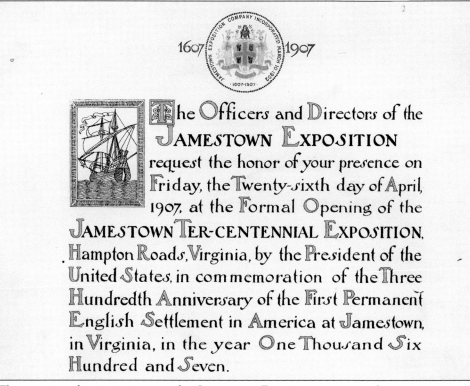

The opening day invitation to the Jamestown Exposition was an elegant enticement to participate in the social event of the season.

Preparing for review on opening day, these United States Army officers gathered to confer on arrangements for the parade. The photograph, taken by William H. Lee on April 26, 1907, is a rare look at the behind-the-scenes pomp that occurred on the exposition's inaugural day.

The cavalry officers in this photograph were escort to President Theodore Roosevelt on opening day, April 26, 1907. The parade took over an hour to pass the grandstand. The president was accompanied by the diplomatic corps, resplendent in their gray uniforms. Governors of participating states and military and naval commanders from American and foreign armies and navies occupied places of honor in the grandstand. (William H. Lee, photographer.)

President Theodore Roosevelt and his second wife, Edith Kermit Carow (1861–1948), proceeded to the reviewing stand, their carriage moving quickly through the streets of the exposition. Roosevelt married Edith on December 2, 1886, two years after the death of his first wife, Alice Hathaway Lee. He had one child with Alice, a daughter named for her mother, in 1884, but five children with Edith: Theodore, Kermit, Ethel Carow, Archibald Bulloch, and Quentin.

Rear Admiral Robley D. Evans, commander-in-chief of the United States Atlantic Fleet, and Major General Frederick Dent Grant, commander of the United States Army's Department of the East, wait for the president of the United States on the reviewing stand. This photograph, taken April 26, 1907, opening day, was a rare glimpse of the passing of the old guard. Evans and Grant represented the end of an era in American military and naval history, one in which former Civil War officers led the armed forces of the United States.

President Theodore Roosevelt was photographed saluting the American flag during the opening ceremony of the exposition.

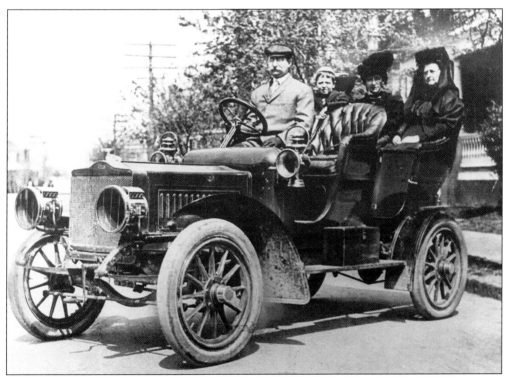

C. Wesley Fentress was taking his family on the 7-mile trip from their home at the corner of Boissevain and Colonial Avenues to the Jamestown Exposition grounds when this photograph was taken in 1907. Fentress owned C.W. Fentress & Company, Butter and Cheese, on Roanoke Docks. The car in the photograph is a 1906 Mitchell, with acetylene headlights and carbide lamps on the sides, indicative of automobiles of the period.

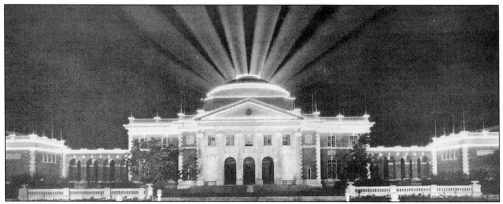

The Auditorium, shown here, contained the Great Organ, where recitals were given daily. Most of the orations and speeches given in celebration of state days were heard in the Auditorium, and other events pertaining to the states were also generally held here. The director general of the exposition and other principal officers of the exposition maintained offices in the Auditorium. The Auditorium (above) was one of the most striking buildings on the exposition grounds when illuminated at night. The scene shown here was shot by an exposition photographer from Raleigh Court. The Auditorium was rivaled by the Government Pier (below), which when illuminated by electric light, was incredibly beautiful.

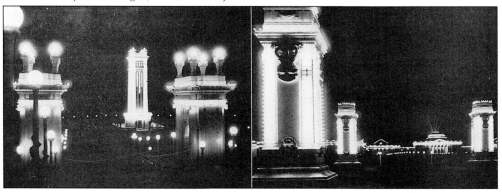

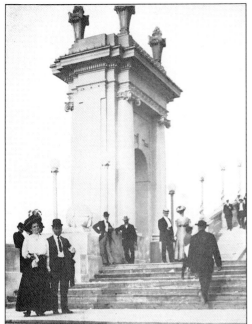 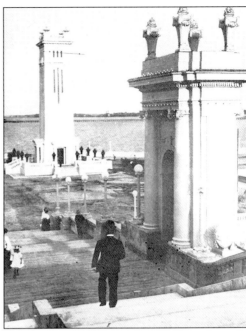

The stairways over the arch at the Government Pier were worth the climb. From atop the arch, visitors had a magnificent view of Hampton Roads, one of the finest natural harbors in the world, and naval vessels of many nations. The people in the photographs shown here seem to be enjoying their excursion to the arch.

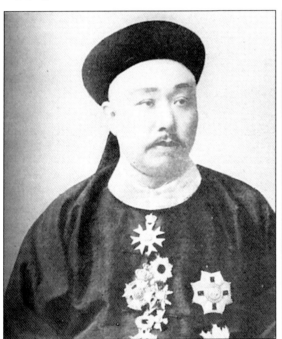 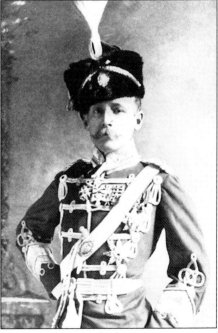

On opening day, President Theodore Roosevelt had many distinguished representatives of foreign nations in his official party, including Minister Sir Chentung Liang-Cheng, ambassador from China (left), and Baron Speck von Sternberg, ambassador from Germany (right).

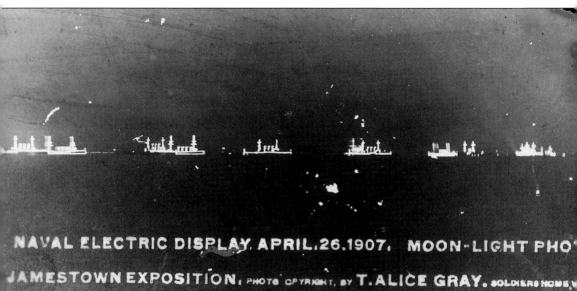

The Navy's impressive armada of battleships, cruisers, and destroyers, later to comprise the Great White Fleet, visited Hampton Roads for key events pertaining to the Jamestown Exposition. The photograph on the postcard shown here was taken on the evening of the opening day celebration, April 26, 1907. The image depicts the fleet lit by electric light. (T. Alice Gray, photographer. Courtesy of the City of Hampton.)

Seven
ON THE WAR PATH

"So on that stage, how wide they little knew,
Each in his part the actors came and went,
Loved, hated, triumphed, suffered, and so passed
Into the silent land, the land of rest.
While of the stately city they had dreamed,
Raising aloft its serried roofs and spires
Stands but one tower, ruined, ivy-grown,
Symbol of time's inexorable change,
Tho' hands that reared it long since turned to clay."

—From *Virginia*, 1907
Mrs. James P. Andrews, of Hartford, Connecticut

Pharaoh's Daughter was a concession based on illusion for entertainment. Pharaoh's Daughter was so successful in Hampton Roads that it was subsequently removed from the exposition and taken to London on tour.

The amusement section of the Jamestown Exposition, known as the War Path, included a rich medley of activities for exposition patrons. Exposition planners spared no expense on diverse attractions to pleasantly pass a summer's day. The photographs are detailed corresponding to their number in the image as follows: 1.) Shooting the Chutes; 2.) Streets of Seville; 3.) Tours of the World; 4.) Temple of Mirth; 5.) A Street in Cairo; 6.) The Old Mill; 7.) Swiss Singers; 8.) Ferrari's Trained Lions; 9.) Deep Sea Divers; 10.) Cycloramas of Manassas and Gettysburg and Battle of the Merrimac [sic] and Monitor; 11.) Esquimaux Village; 12.) Ostrich Farm.

One of the most alluring places, and the decided thriller on the War Path, was Hell Gate, its spire pointed heavenward and its broad stairs leading to a wide-open entrance. Once patrons moved within the charmed circle, they glided over its swirling waters, round and round, sailing smoothly on until the whirlpool was reached and patrons went down into the earth. Dark caverns confronted visitors; reptiles, including snakes and lizards, were encountered; and grottos with wicked scenes of demons and tortured humans passed by until everyone exited. Upon reaching daylight, exposition-goers were left rather astounded at the experience of Hell Gate.

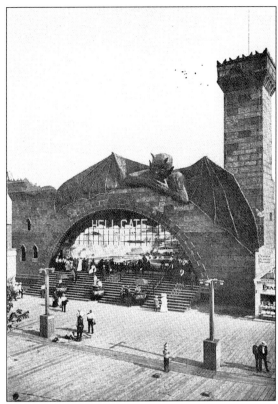

Billed as a "fearless woman," Beautiful Seleca danced among the lions, part of Ferrari's Wild Animal Show.

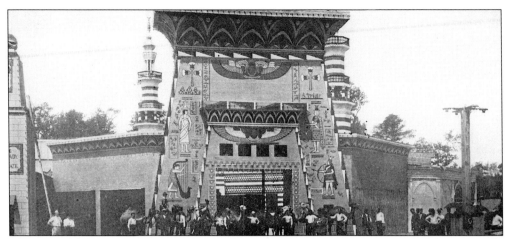

The Beautiful Orient and Streets of Cairo, located at the extreme western end of the War Path, was the creation of Gaston and Ferdinand Akoun. The Streets of Cairo became the place in which fantasies came true during the exposition. Throngs of gaily dressed Arabs surrounded by camels, donkeys, and bazaars gave visitors a taste of the Middle East and North Africa, which was both inviting and entertaining. The concessions included a Turkish theatre, musicians, dancing girls, and oriental prestidigitators performing their tricks.

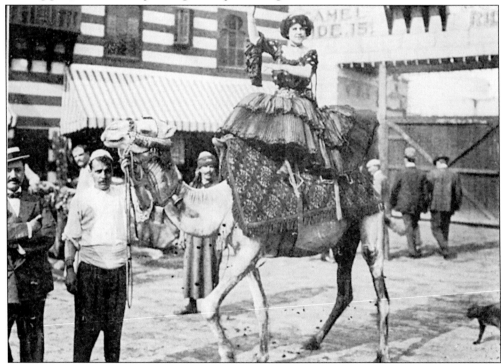

The highlight of the Streets of Cairo was Princess Rajah, her terpsichorean offerings considered a great artistic performance. Princess Rajah, perched atop a camel, was a belly-dancer known around the world for her craft. The Beautiful Orient, also part of the Akoun exhibit, included rug bazaars with low-grade Smyrnas, precious Daghistans and Bokharas, and still more valuable, India prayer rugs from Madras. The elaborate embroideries from Persia (now Iran), Arabia, and Turkey were considered excellent goods to buy at the exposition.

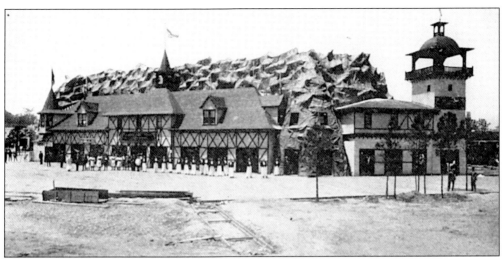

The Swiss Alps Village added to the international appeal, hence the world's fair atmosphere, of the Jamestown Exposition. The image shown here demonstrates the elaborate buildings constructed to entertain patrons. Operated by Fritz Muller & Sons, proprietors of the Swiss Alps Village, this popular attraction, a restaurant, was a reproduction of a Swiss chalet with simulated snow-clad peaks as a backdrop.

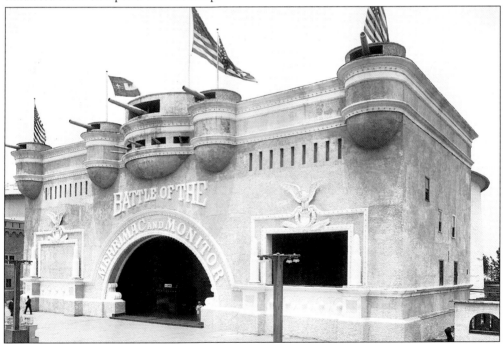

The Battle of the Merrimac [sic] and Monitor, a faithful recreation of the famous Battle of the Ironclads in Hampton Roads on March 9, 1862, was the most successful exhibition on the War Path, even though it did not open until several weeks after the Jamestown Exposition had opened. Run under the auspices of concessionaire Emmet W. McConnell, the Battle of the Merrimac [sic] and Monitor's success was due in large measure to the realistic designs of nationally known exhibit designer E.A. Austin. This exhibit proved to be his crowning achievement.

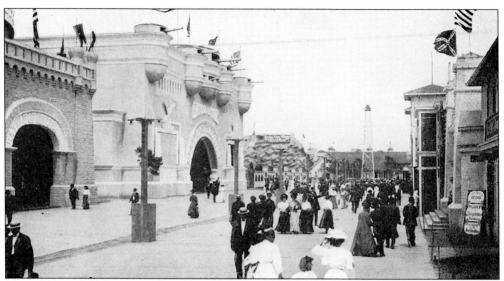

The War Path was laid out in a square, bringing the various attractions close together and making them easily accessible. The scene shown here was taken near the Battle of the Merrimac [sic] and Monitor.

One of the most intensely interesting exhibits on the War Path demonstrated the apparatus and methods of deep-sea diving. The exhibit was aptly titled, Deep Sea Divers, and ticket sales to this area were brisk. The Deep Sea Divers exhibition was operated by Captain Louis Sorchow, a veteran submarine crewman and an experienced concessionaire. Sorchow's exhibit demonstrated divers in full harness working in a glass tank filled with seawater. (William H. Lee, photographer.)

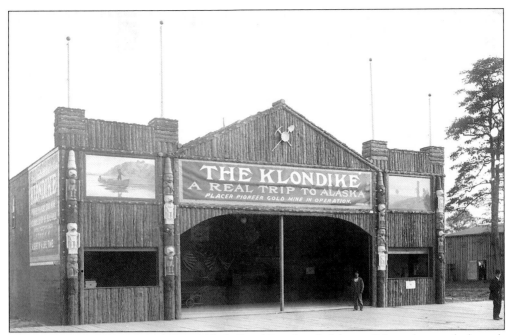

The Klondike, billed as "a real trip to Alaska" and "a sight of a lifetime," drew thousands through its entrance. The Klondike gold mine exhibited cross-country trips on dog sledges and methods used to extract gold from placers or deep diggings.

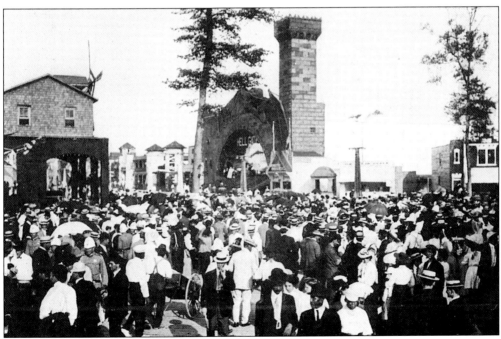

Exposition visitors choked the walkways of the War Path, slowly making their way to the next amusement. The photograph shown here is interesting for the depth and variety of attractions, but also for the large number of African-American visitors in the foreground of the photograph.

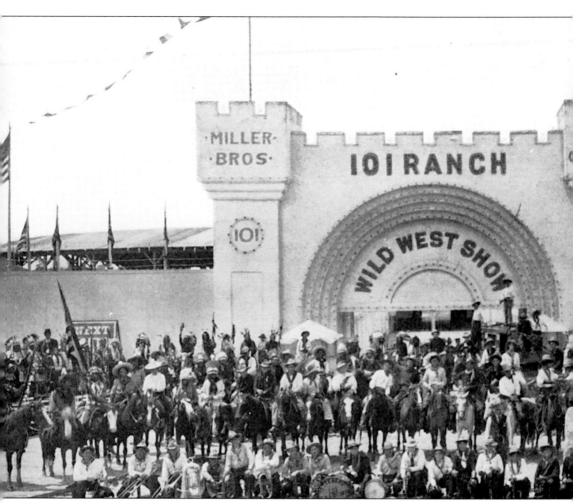
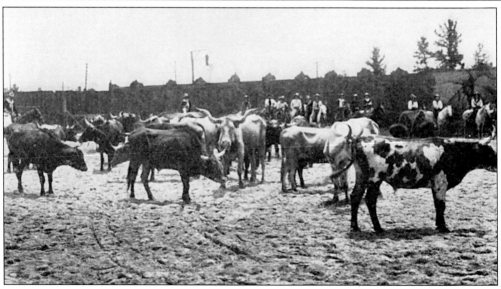

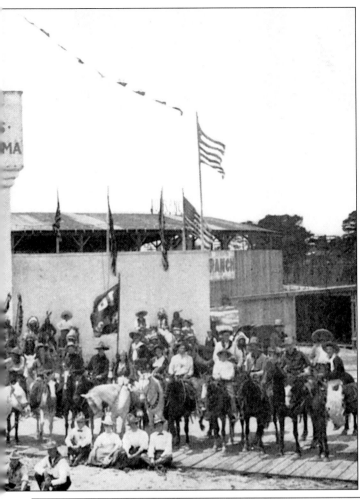

The Miller Brothers 101 Ranch from Bliss, Oklahoma, was located just outside the War Path, where exposition organizers believed they would draw their own crowd as an isolated, but incredibly large, attraction. The only other "amusement" near, but not on, the War Path was the Philippine reservation. The Miller Brothers 101 Ranch operated a typical Oklahoma ranch show including an array of cowboys, cowgirls, Mexicans, and Native Americans, and encompassed bucking broncos, lassoing wild steers and buffalo (shown below), Native American dances, and other acts. The ranch proved one of the most popular attractions.

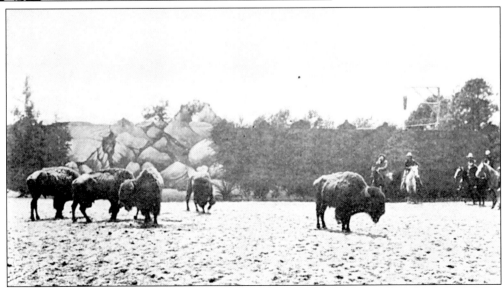

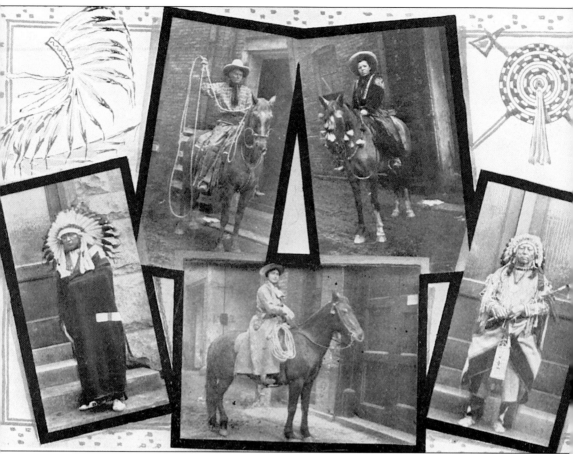

The Miller Brothers 101 Ranch was one of the country's most popular Wild West shows, having a large number of performers such as those shown in this photograph. Before each performance, performers paraded through several streets of the exposition to let people know they were about to begin. To many patrons, this was a show unto itself.

Eight
THE WORLD'S FAIR IN HAMPTON ROADS

"Shall we? Shall we go on conferring our Civilization upon the peoples that sit in darkness, or shall we give those poor things a rest? Shall we bang right ahead in our old-time, loud, pious way, and commit the new century to the game; or shall we sober up and sit down and think it over first? Would it not be prudent to get our Civilization-tools together, and see how much stock is left on hand in the way of Glass Beads and Theology, and Maxim Guns and Hymn Books, and Trade-Gin and Torches of Progress and Enlightenment."
—From *To the Person Sitting in Darkness*, 1904–1905*
Mark Twain (1835–1910)

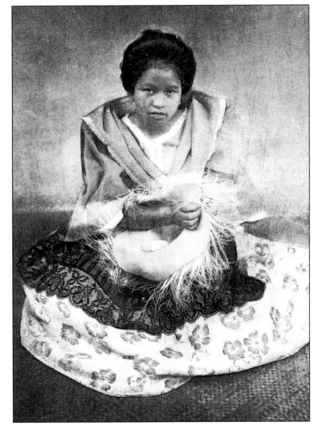

This hand-colored postcard depicts a young native Filipino girl, c. 1910.

*Samuel Langhorne Clemens, a.k.a. Mark Twain, derived the title to this piece from Matthew 4:16, which reads: "The people which sat in darkness saw great light; and to them which sat in the region and shadow of death light is sprung up."

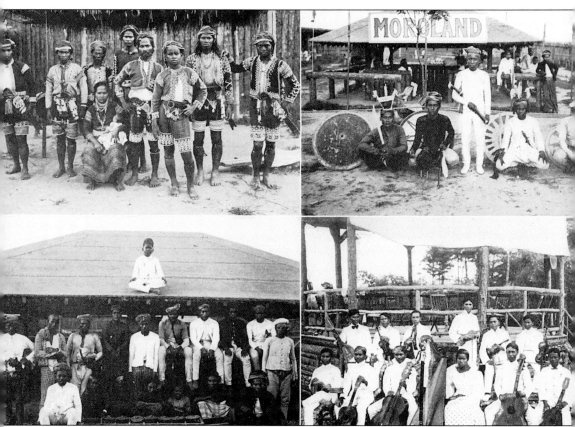

The Philippine Reservation was one of the most popular features of the Jamestown Exposition, covering about 5 acres of the grounds abutting the Canoe Trail. One hundred and forty-seven Philippine nationals, representing five different races and native tribes, exhibited at the exposition, though they were not present when the exposition opened in April. The Philippine representatives arrived later, according to newspaper accounts of April 29, 1907, because the weather was not warm enough for their style of dress. The long-haired Bagobos (top left) and Moro warriors (top right) were among them. The Moros were touted as "the most bloodthirsty people of the Islands," and are shown in this image in a village of which Prince Sansaluna was head. Prince Sansaluna (center of the photograph, top right), only 17 years old at the time of the exposition, was the absolute ruler of his people. The prince is pictured (below left) with his slaves. The long-haired Bagobos, the first to ever make an appearance in the United States, put together an interesting village in which they demonstrated beadworking and other pastimes for which they were known. The Bagobos were among the most ethnic minorities of Philippine native peoples, numbering hardly 2,000 today and residing primarily in the west and northwest region of Davao Gulf on the island of Mindanao. It was once the goal of all young Bagobo men to achieve *bagani*, meaning any warrior who killed more than one enemy. In the center of the reservation was a bandstand in which the Aguinaldo Orchestra, a musical hit at the exposition, gave daily concerts. They are pictured here (below right). The Aguinaldo are mentioned in the April 7, 1906 poem by D.A. Ingham titled *Manifest Destiny*, in which the poet wrote the following lines: "Not even when torture of natives / Was woven into a jest, / Nor capture of Aguinaldo / Through cunning ruse of a guest." The Philippine Reservation contained an exhibit hall to display Philippine products; a trades building; the bazaar building in which native women wove jusi and pina cloth; iron and wood shops; the Moro fort; and the five villages of the Ilocanos, Visayans, Tagalos, Moros, and Bagobos.

Extermination and Invitation

The Jamestown Exposition's invitation list to participate in the world's fair in Hampton Roads was riddled with oxymorons, particularly when attention turned to the invitation of Philippine native tribes to take part in the event. At the height of American imperialism, the United States circumnavigated the world looking for foreign lands to dominate. In fulfilling the United States' manifest destiny abroad, thousands of native peoples fell to American military superiority and technology. The Philippines were considered a strategic military enclave in the Pacific, a prize of war when American forces, including Theodore Roosevelt's Rough Riders, defeated Spain in the Spanish-American War.

Major General Leonard A. Wood, a former Rough Rider, led United States troops against the Moros, a tribe of Muslim Filipinos, during the infamous massacre that occurred at the Battle of Mount Dajo in the Philippines in the early days of March 1906. Ironically, and perhaps sadly, Wood was later appointed the governor general of the Philippines, carrying on the American imperialism, which proved so fatal to over 900 native Moros(1) who were slaughtered by American troops in one engagement. Though President Theodore Roosevelt praised Wood and his troops as having "upheld the honor of the American flag," the American public was divided over the moral questions surrounding this gruesome incident. A story in the *Boston Daily Advertiser* by Moorfield Storey (1845–1929), a nationally prominent attorney and president of the New England Anti-Imperialist League, wrote of the massacre of a primeval people: "No prisoners were taken. No wounded remained alive when the conflict was over and 600 human beings were slain without mercy. Not even women and children in the villages were spared. Every American must regret deeply when any of our brave countrymen are killed or wounded, but that regret must be far greater when they are sent to their deaths for such work as this." Storey continued: "Suppose we had heard that the British had dealt thus with a Boer force, that the Turks had so attacked and slaughtered Armenians, that colored men had so massacred white men, or even that 600 song birds had been slaughtered for their plumage, would not our papers have been filled with protests and expressions of horror? They 'recognized no chief and had been raiding friendly Moros.' What was their side of the story? No man lives to tell it. They have been exterminated. Is it possible that this is all the greatest and freest nation in the world, as we like to believe ourselves, can do for a people over whom we insist on extending our benevolent sway?"

The carnage in the Philippines had been so horrific, authors and poets took full license to print their feelings in eloquent fashion. Poet C.E.S. Wood was prompted to pen his poem *Glory* (April 21, 1906), "dedicated to the perpetrators of the Moros massacre, the President, Congress, and General L.A. Wood": "I weep for the little children who shall never play again; / The little children of the slim soft limbs, so full of grace. / I have seen these naked little children lying about like broken toys. / Their fat little arms and legs tossed about as if they were asleep. Dead! / Their chubby bodies naked and glistening; / Their laughter forever hushed. Ended their childish joy of living . . ." American humorist and author Samuel Langhorne Clemens was so outraged by the incident, he recorded in his autobiographical journals, published in a two-volume set by *Harpers* in 1924, the following passage:

> They [the Moros] *were mere naked savages, and yet there is a sort of pathos about it when that word children falls under your eye, for it always brings before us our perfectest symbol of innocence and helplessness; and by help of its deathless eloquence color, creed and nationality vanish away and we see only that they are children—merely children. And if they are frightened and crying and in trouble, our pity goes out to them by natural impulse. We see a picture. We see small forms. We see the terrified faces. We see the tears. We see the small hands clinging in supplication to the mother; but we do not see those children that we are speaking about. We see in their places the little creatures whom we know and love.*

Clemens clearly fell on the anti-imperialist side of the argument as serious moral and constitutional questions were raised regarding wholesale massacre of a race of people, especially

as plans were made for the exposition, and the Moros who survived the incident a little over a year before were asked to participate in the exposition in Hampton Roads. Contrary to newspaper accounts and exposition literature, Prince Sansaluna ruled over approximately 100,000 Moros. The son of the late Datto Ali had dominion over considerably few men, women, and children. Prince Sansaluna's father had been killed by United States Army troops.

1. The number of Moros massacred on the island of Jolo exceeded 900.

Navigating the waterways of the Philippines, the casco in this photograph snakes its way through dense shoreline foliage to get to its destination. The image, shown on a postcard c. 1915, depicts a familiar scene and a mode of transportation that American forces occupying the islands at that time would have had to use themselves to travel from place to place. The casco is one of three primary modes of travelling the inland waterways of the Philippines. A casco is of equal breadth at either end and has more the appearance of a raft than a boat. The implementation of a casco has not changed over its long history of use. Generally used to transport heavy merchandise, the casco is favored by the natives.

His Royal Highness Luigi Di Savoia, Duke D'Abruzzi, commanding officer of the Italian Royal Navy (IRN) *Varese*, was engaged in conversation with Japanese Imperial Navy (JIN) Vice Admiral Goro Ijuin when this photograph was taken on May 13, 1907, on the occasion of Jamestown Day at the exposition.

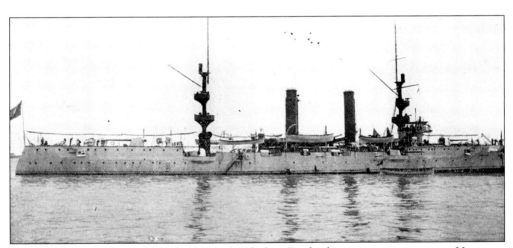

The Brazilian Navy sent the third-class battleship *Riachuel*, carrying ten guns, to Hampton Roads as part of the international naval review at the Jamestown Exposition. The *Riachuel* was the flagship of Rear Admiral Duarte Huet de Barcellar.

The International Bureau of American Republics included exhibits from Mexico and Puerto Rico. Although the Jamestown Exposition Company never officially declared the event an international exposition and no invitations were formally sent to foreign countries, the attendance by nations of the world was enormous. The International Bureau of American Republics made an impressive showing with its Spanish-style building in the northeast corner of the grounds. The bureau's exhibit demonstrated the commercial possibilities of Latin America, and several individual republics participated no doubt because the bureau encouraged them. The first Pan-American Conference was held in 1890 in Washington, D.C., and as a result, the International Bureau of American Republics was established. Twenty-one governments were represented on its board.

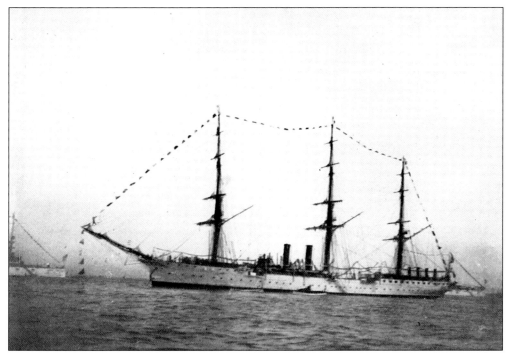

The Argentine cruiser *Presidente Sarmiento* was a 2,750-ton, 2,200-horsepower training ship. It carried four guns. Argentina, Chile, and Brazil were the only South American countries to send warships from their respective fleets to the exposition. Brazil brought the battleship *Riachuel* and the cruiser *Tamoyo* to Hampton Roads.

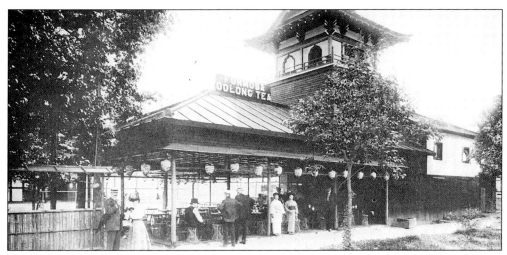

The Formosa Tea Garden was situated next to the Palace of Manufactures and Liberal Arts. The Formosan government operated the tea garden to showcase the merits of Formosa tea for the American people. Thousands of visitors to the exposition sipped the refreshing iced tea served during the hot months that the event dragged on, taking away generous free samples to be sipped and drunk in their own homes.

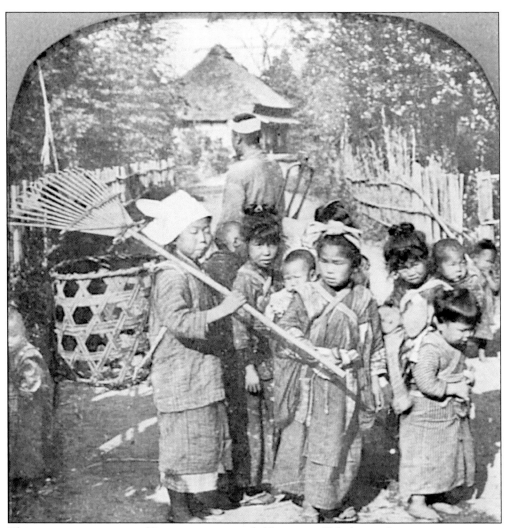

This stereoscopic image of Japanese peasant children near Yokohama, Japan, was in a series published at the turn of the century depicting life throughout the country. The stereoscope was enormously popular as a form of entertainment and was sold widely at the Jamestown Exposition. The back of the card, typical of America's racial perceptions of the period, noted that "good nature and poverty seem to be the chief characteristics of the peasants, and their best possessions consist of their rosy and chubby children, who all through Japan are much made of by their parents. The country has been called the 'paradise of babies.' The great children's day in Japan is the fifth day of the fifth month, when the toys of the children are displayed in every house. At this time hundreds of hollow paper fish are floating in the air, held by long strings to bamboo poles." From 1851 to 1935, nearly every international and consequential exposition was recorded in stereoscopic form, and in every case by more than one photographer or publisher. The splendor of the expositions as well as the racial messages about the colonies were reproduced in stereoscopic images that could be purchased as souvenirs or, for those who could not attend the events, as a way of experiencing the fairs and expositions from a distance in realistic 3-D fashion. Keystone View Company distributed images of the Jamestown Exposition in an educational series meant for elementary school curriculums. The Japanese promoted as much of their authentic culture as possible, though the stereotypes were firmly in place.

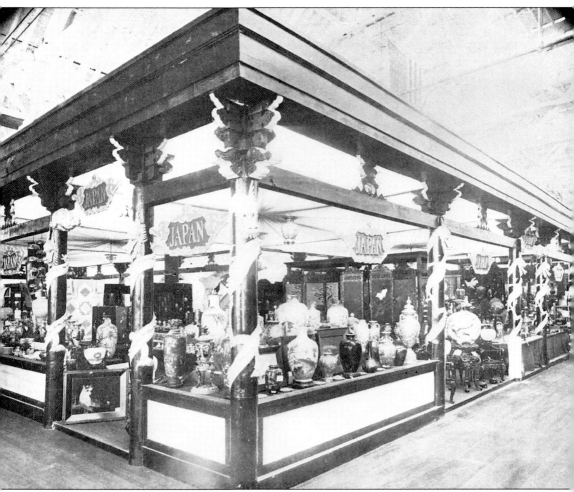

The Japanese exhibited their finest works of art in the Palace of Manufactures and Liberal Arts. There were thousands of pieces for visitors to see. Japan led all foreign nations at the Jamestown Exposition in the size and quality of its displays. During the spring of 1907, roughly 60 Japanese manufacturers formed an association, and although this group did not represent Japan's government, they received official recognition and $15,000 from Japan to build exhibit space. Among the officers representing the Japanese exhibitors were Yumeto Kushibiki, commissioner general, and Yoshitsugu Hashamoto. The exhibits came primarily from Tokyo, Yokohama, Kyoto, Nagoya, Kobe, Ishikawa, and Satsuma. The cloisonné, porcelain, Satsuma ware, potteries, embroideries, textiles, brassware, ivory carvings, perfumeries, toilet articles, paintings, toys, kites, willows, baskets, carpets, and rugs occupied a space of over 4,600 square feet.

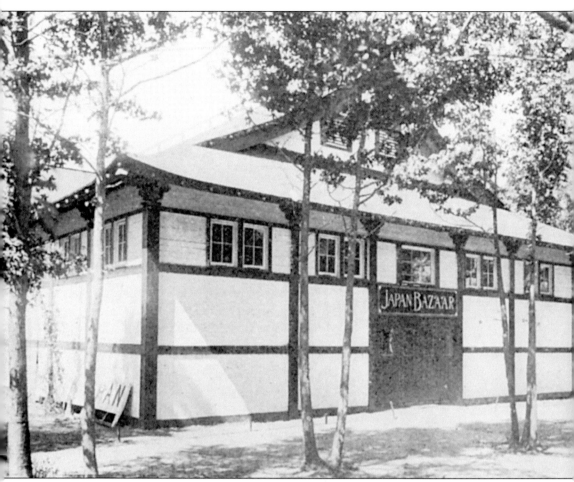

Items on display in the Palace of Manufactures were not for sale, so the Japanese association built a building they called the Japanese Bazaar, just west of the palace, and this structure, which contained an area in excess of 6,000 square feet, was entirely devoted to the sale of Japanese good. The bazaar area, despite its size, proved too small to hold all the items for sale, so the Japanese took over the entire northeast wing of the exposition's bazaar building at the head of the War Path to sell goods.

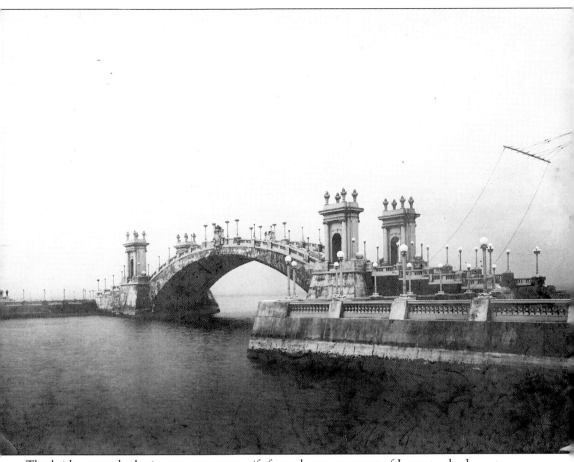

The bridge over the basin entrance was a gift from the government of Japan to the Jamestown Exposition. The Japanese government celebrated Japan Day on October 2. In an address by Dr. T. Fukushima, of Tokyo Academy, the professor remarked, "Fifty years ago, Japan was asleep and it was the American people who coming had found a great people and introduced them to civilization, and the friendship between the two powerful nations, which then began, has continued and will continue forever." The basin bridge represented the friendship that the Japanese people sincerely felt for their American counterparts. Shortly after the Japanese attack on Pearl Harbor, December 7, 1941, the bridge was destroyed and added to the tons of rip-rap ringing the shoreline off Naval Air Station Norfolk. As an aside, Fukushima was an alumnus of Cornell University.

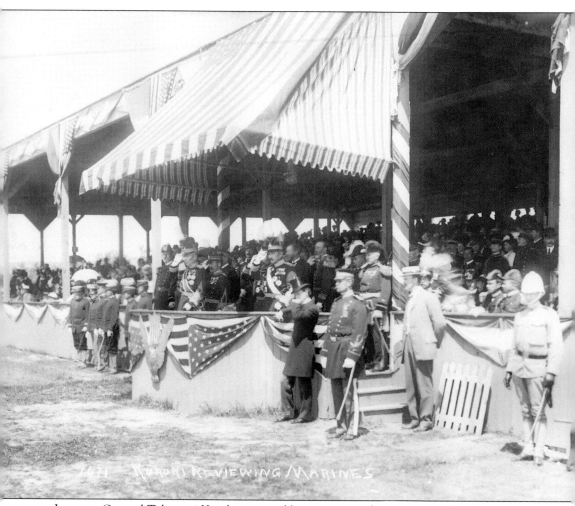

Japanese General Takemoti Kuroki reviewed his marines at the exposition. Kuroki was born in Satsuma fief in southern Kyushu in 1844. He is principally remembered for his tactical brilliance and sweeping defeats of the Russians in the Russo-Japanese War (1904–1905), which Japan won. Kuroki was, however, involved in Japan's most significant wars prior to the Second World War, including the Restoration War (1868); Satsuma Rebellion (1877); and the Sino-Japanese War (1894–1895). He gained his highest recognition in the Japanese military structure for his routing of a smaller Russian force at the battles of the Yalu River, April 30 to May 1, 1904; Liaoyang, August 25 to September 3; and, again, his command of Japanese forces at the Sha Ho, in which his First Army repelled a Russian army, led into the fight by General Aleksei Nikolaevich Kuropatkin (1848–1925) between October 5 and 17, 1904. Kuroki distinguished himself again at Mudkin, also known as Shenyang, in February and March 1905. He was never rewarded with a promotion to field marshal for his battlefield successes, and retired in 1909. Military historians have long concluded that Kuroki was not advanced to field marshal because of capriciousness of Japanese leadership toward career military officers out of their political camarilla. Kuroki was designated a count and eventually served as a privy councillor from 1917 until his death in 1923. It is interesting to note that Kuroki attributed much of his army's battlefield success to the training of Japanese officers in Germany in the late nineteenth century.

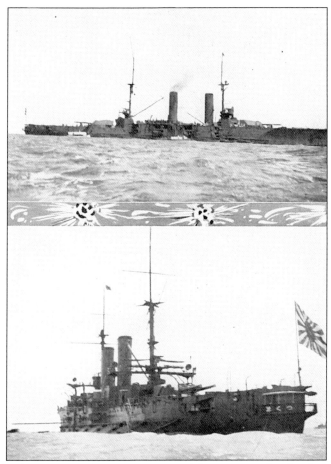

The *Tsukuba* (top), an armored cruiser carrying 16 guns, was the flagship of Vice Admiral Goro Ijuin (1852–1921). Ijuin was known primarily for his participation in the Boshin War (1868); the Taiwan Expedition in 1874; and the Satsuma Rebellion three years later. Ijuin, like Takemoti Kuroki, was a veteran of Satsuma, a painful chapter in Japan's national wars. The *Tsukuba* was the lead ship of its class of semi-battlecruisers, essentially an extremely powerful class of armored cruisers, often considered battlecruisers and reclassified as such in 1912. By the time the *Tsukuba*-class was reclassified, they were obsolete. The construction of keel-up battlecruisers forced the Imperial Japanese Navy to reclassify them first-class cruisers in 1921. The *Tsukuba* was built by the Kure Navy Yard, her keel laid on January 14, 1905. The *Tsukuba* was launched on December 26, 1905, and finished on January 14, 1907. Ijuin's flagship was a new vessel when she appeared at the Jamestown Exposition, but plagued by a number of serious construction flaws. The *Tsukuba* was sunk by a magazine explosion in Yokosuka Bay on January 14, 1917, but was later raised and scrapped. The *Chitose* (bottom) was a protected cruiser carrying 12 guns. The *Tsukuba* and *Chitose* are indicative of the meteoric rise of the Imperial Japanese Navy since its official recognition by the government in 1893, and the country's aggressive shipbuilding program. Foreign naval and commercial vessels entering Japan's harbors quashed the notion of Japanese nationalism in the late nineteenth century. No longer could the Japanese remain divorced of the world community. Though most of Japan's first warships were built overseas, shipbuilding gradually became a native industry, and a successful one but for construction blunders driven by the desire to turn out ships too quickly. The pictures shown here were taken during the exposition.

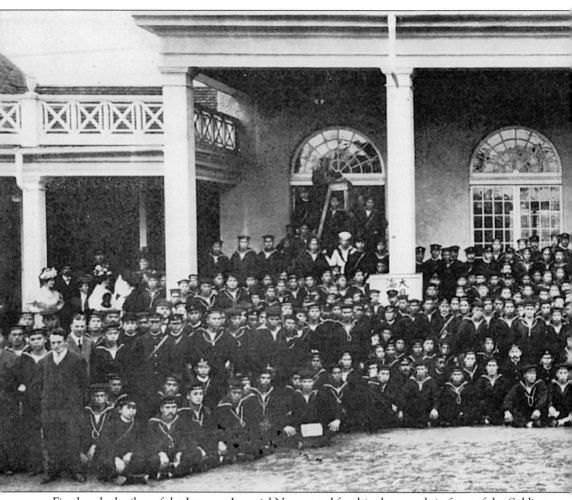

Five hundred sailors of the Japanese Imperial Navy posed for this photograph in front of the Soldiers and Sailors Club at the Jamestown Exposition. They were stationed aboard the Japanese Imperial Navy

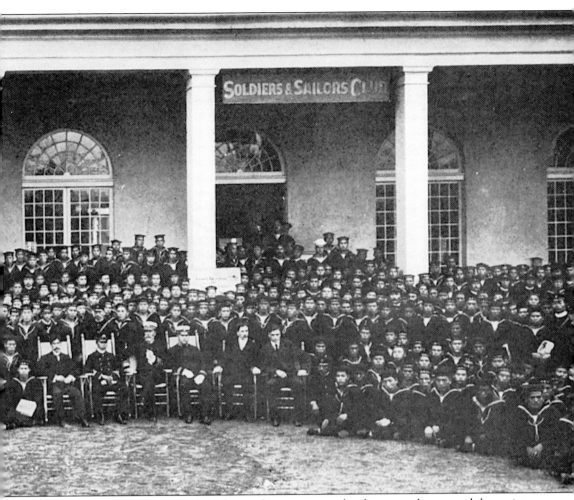

cruisers *Tsukuba* and *Chitose*. Each of these sailors was reported to have eagerly traversed the entire exposition grounds, taking in all there was to see. The naval exhibits were of greatest interest to them.

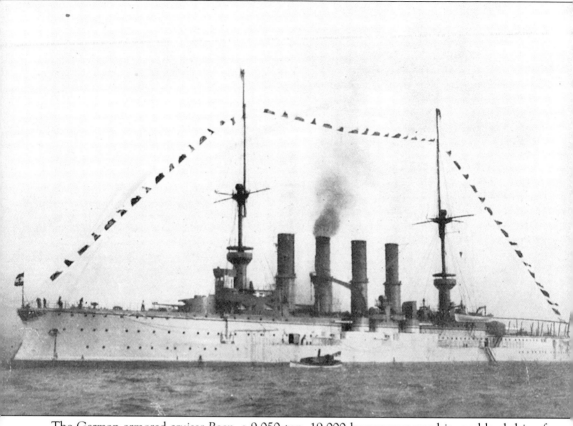

The German armored cruiser *Roon*, a 9,050-ton, 19,000-horsepower warship, and lead ship of her class of *kreuzers*, carried 14 guns and was the flagship of Rear Admiral Zimmermann. The *Roon* was built at Kaiserliche-Werft, Kiel, Germany. The cruiser's keel was laid on August 1, 1902, and though she was launched on June 27, 1903, the *Roon* was not commissioned until 1906. She saw fleet service until 1916, and five years later, the Imperial German Navy sold her for scrap. Though the German *Roon*-class *kreuzers* were efficient and could get up to 21 knots, they were not very menacing warships. The *Roon* was accompanied to the Jamestown Exposition by the *Bremen*, a 3,250-ton, 11,000-horsepower light cruiser with ten guns built at Weserferft in Bremen. She was launched on July 9, 1903, and commissioned May 19, 1904. The *Bremen* was in service until 1913 when the *leichten kreuzer* was modernized at Kaiserliche-Werft, Wilhelshaven, between 1913 and 1914. The *Bremen* served in the Baltic Sea until 1915 when she hit a mine and sunk off Windau on December 17, during the First World War. Like most of the foreign naval vessels participating in the exposition's naval review, the hulls of the German ships were painted dark gray, forming a sharp contrast to the white hulls of the American fleet.